Photographer's Filter Handbook

A Complete Guide to Selection and Use

STAN SHOLIK AND RON EGGERS

AMHERST MEDIA, INC. ■ BUFFALO, NY

Published by:
Amherst Media, Inc.
P.O. Box 586
Buffalo, N.Y. 14226
Fax: 716-874-4508
www.AmherstMedia.com

Publisher: Craig Alesse
Senior Editor/Production Manager: Michelle Perkins
Assistant Editor: Barbara A. Lynch-Johnt

ISBN: 1-58428-068-9
Library of Congress Card Catalog Number: 2001 132039

Printed in Korea.
10 9 8 7 6 5 4 3 2 1

TABLE OF CONTENTS

TO LINDA AND AMELIA FOR THEIR LOVE, PATIENCE AND SUPPORT . . .
AND FOR AMELIA'S WONDERFUL PHOTOS.

—STAN SHOLIK

TO MARGO, WHOSE SUPPORT IS UNWAVERING.

—RON EGGERS

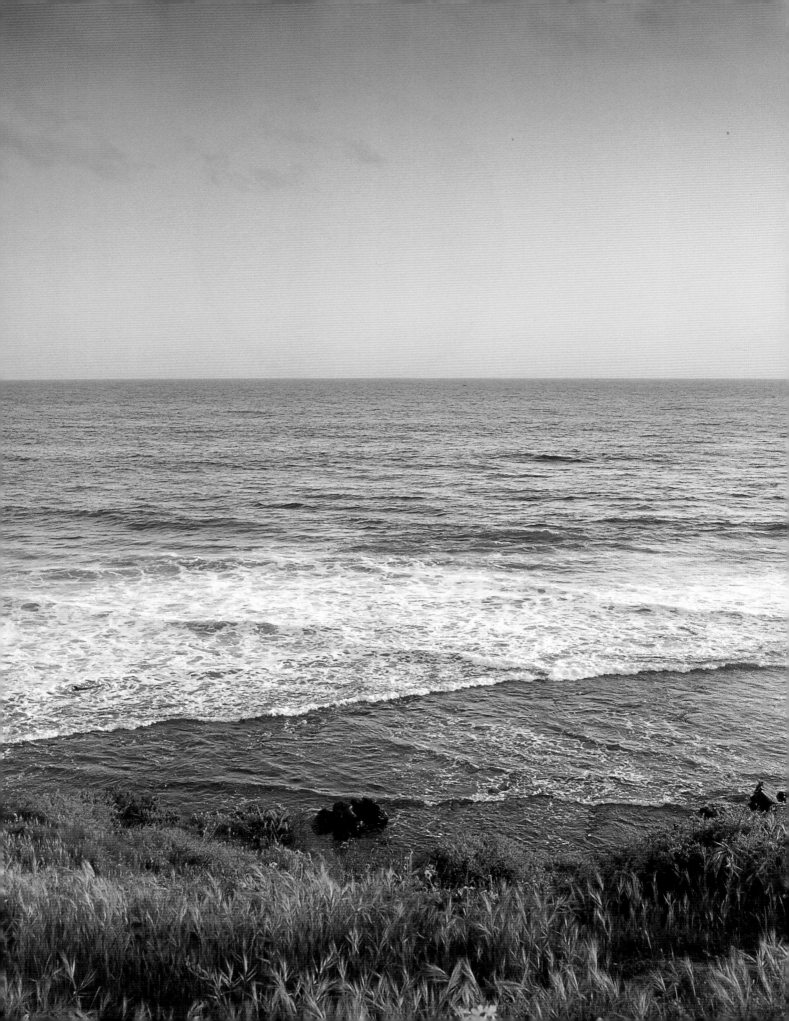

INTRODUCTION

At its most basic level, photography is simply the process of capturing light on sensitized material. However, anyone who's taken a picture knows it's much more than that. On one hand, it's a way to objectively record a scene, but on the other, it allows us to subjectively interpret a subject. Both of those considerations are important. In fact, this dual nature of photography is one of its most interesting qualities.

All too often, there is a discrepancy between what a photographer wants to capture on film and what is actually recorded there. While most photographers want to render a scene in a way that relays the impact they felt when they came upon it, creating a subjective representation of that image, they find that the camera sometimes distills the emotional charge from images. That's because the photographer mentally interprets and emotionally responds to the scene, while the camera simply records it.

There are actually a number of factors that contribute to this problem. One is that the photographer and the camera "see" things differently. While, in some respects, technology has extended the light-capturing capabilities of cameras, lenses and film beyond those of the human eye, the eye is still a more sophisticated imaging device. It can see and adjust to subtleties and changes in a whole range of light values much more effectively than even the most sensitive light-capturing devices. Of course, the brain takes the visual information captured by the eye and interprets, enhances and modifies it in a number of ways. Though the photographer might have seen detail in the backlit foreground subject and detail in the clouds, the photo may completely lack shadow detail, and the clouds in the sky may end up looking a washed-out gray. Similarly, when shooting interiors, the pictures may come back with areas of yellow and green light rather than

FACING PAGE: The most successful images will evoke an emotional response from the reader equal to the feeling the photographer had when viewing the scene. Filters can aid this communication, such as the feeling of a romantic sunset achieved with a Lee Sunset Red filter for the sky and a Twilight Blue filter for the water.

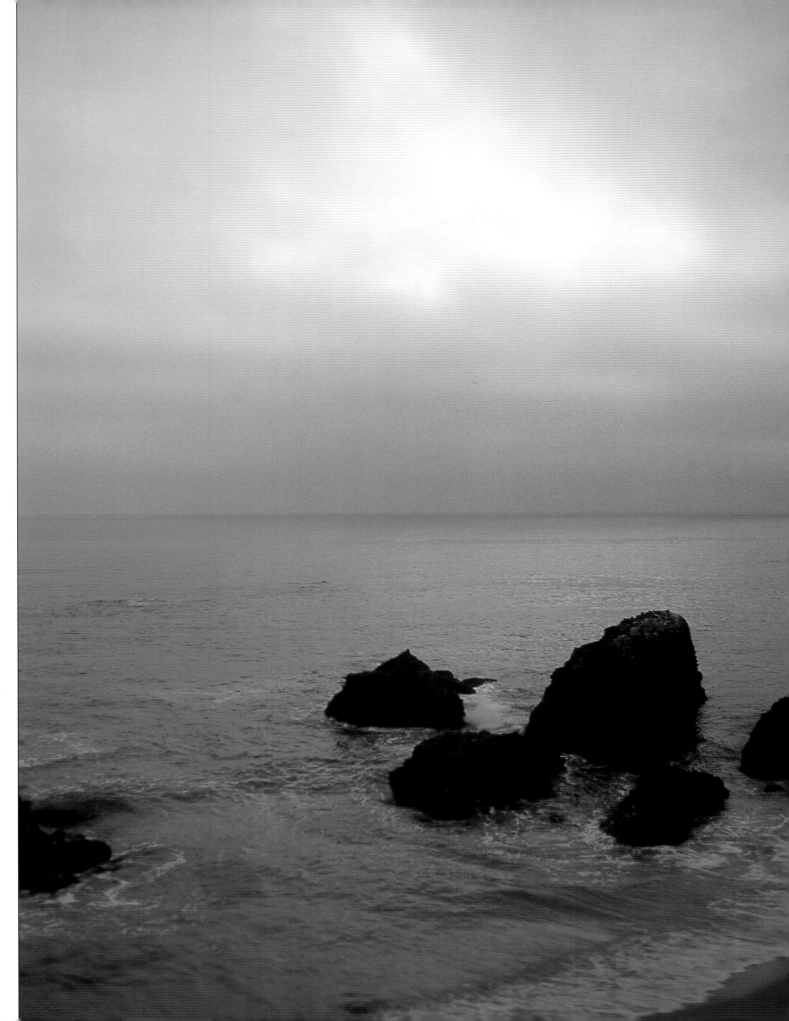

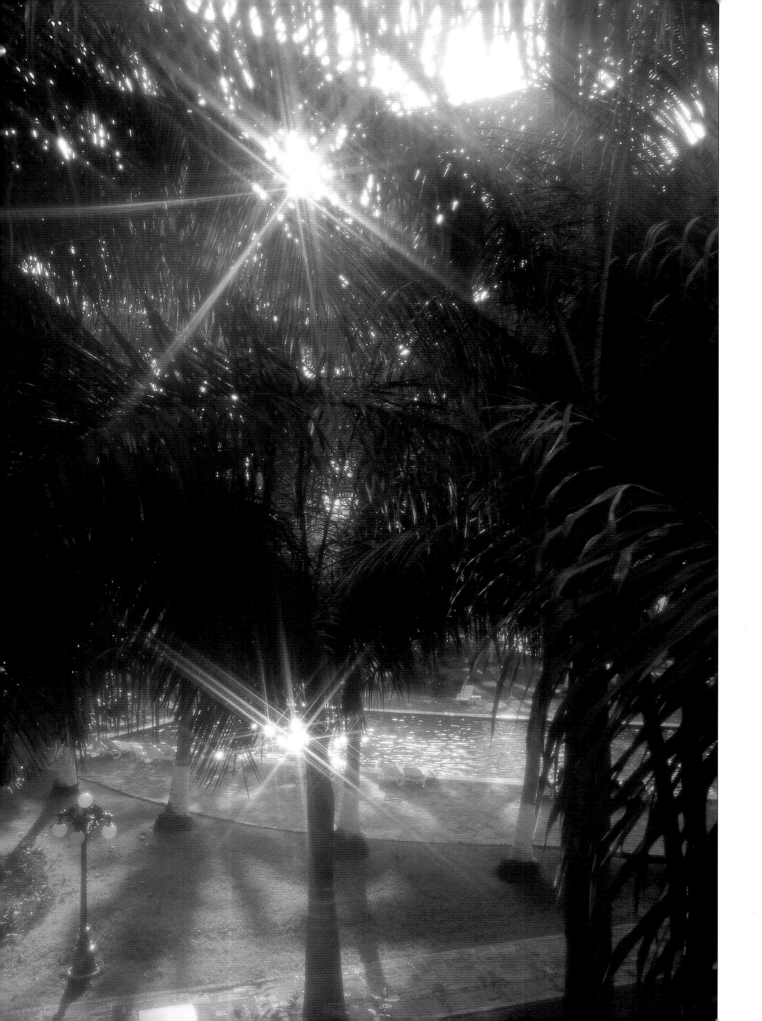

Some images need more saturation than even the most saturated films, like Kodak 100VS, can deliver (left photo). Using the correct filter (in this case a red-enhancing filter) can provide the needed "punch" (right photo).

the natural color the photographer saw through the viewfinder.

There's also a flip side: the camera is capable of sheer objectification. A camera can record details and imperfections that the eye can't see or the mind overlooks. Portraits taken with today's ultrasharp film often render skin texture accurately, for instance, which isn't always flattering. Because of the significantly enhanced capturing capabilities, photographers are sometimes disappointed that their processed film does look like the scene they photographed.

Photographers, like most artists, are interpretive by nature. The more they shoot, the more they want to make a visual statement of their emotional response to their subject. This is particularly true for those working in black & white, which has traditionally been the primary medium for creative photographers. But black & white film will not mag-

FACING PAGE: A star filter, here combined with diffusion, helps to communicate my emotional response to the bright tropical morning sun shining through the trees and reflected off the pool in this romantic Mexican resort hotel.

ically render a scene or subject creatively. In fact, black & white film presents unique concerns for the photographer; it often poorly depicts the visual contrast the photographer saw and attempted to reproduce on film.

Faced with these difficulties, a photographer may feel victimized by his or her image-making, not inspired by, or in control of it. Don't hang up your camera bag just yet. There is hope.

You guessed it. This is where filters come in. This book will enable photographers to select filters that will beautifully render "reality" as seen by the human eye, or to enhance that reality, yielding a subjective interpretation of a scene. It will help photographers overcome some of the perceived limitations of photography and inspire creativity, experimentation and self-expression.

● FILTER BASICS

The first filter purchased by many photographers is one that protects the lens. After that, filters are purchased for a specific need. For portrait photographers, it might be a softening filter; for landscape photographers, a

It is important to be able to manually stop down the camera lens to visualize the effect of using a graduated filter (like this two-stop neutral density), especially with wide-angle lenses. By stopping down, the exact position of the beginning of the gradation can be seen, as well as how quickly the transition from the unfiltered to the filtered area occurs. The unfiltered photo is shown on the left for comparison.

polarizing filter to darken the sky and increase the color saturation of the scene; for those working with black & white film, it might be a yellow or red filter that increases contrast. These are just some of the basic filters available; in fact, the selection of filters from which to choose is growing all the time. There are so many filters on the market that photographers who take a camera along on their travels might have trouble deciding how many to pack. Some filters can turn dull sunsets into spectacular events, while others can warm a portrait shot under an overcast sky or eliminate the reflection in a store window so objects inside can be seen more clearly.

While some photographers use filters to better depict reality, others employ them to achieve special effects. The results can be subtle, as when using a star filter to photograph the family Christmas tree or more obvious, as when shooting the sun with a diffraction filter. Stationary subjects can be put in motion with "speed" filters and single objects can be repeated in a mosaic pattern with multi-image prism filters. These are just a few of the ways that using filters can impact your photography.

◉ LEVEL OF EXPERTISE

It is assumed that the reader has a solid understanding of camera operation and exposure fundamentals and a basic understanding of lighting principles, depth of field and other photographic considerations. While many filters can be used in a camera's "programmed automatic" mode, others require the ability to set the camera's aperture ("aperture priority" mode), shutter speed ("shutter priority" mode) or both ("manual" mode). It's important to be familiar with these operating modes in order to get the most from this book.

◉ EQUIPMENT

The camera brand or model used isn't as important as its features and capabilities when studying the techniques used in this book. There are several camera features that are nice to have, however. One is the ability to stop the lens down to its taking aperture so that the effect of the filter can be previewed and evaluated. This is important for a number of different types of filters. Another is the ability to spot meter different areas of the scene. Both capabilities will be discussed in detail later.

Lenses. The brand of the lens that the filter is being used on is not that important, but the way in which the lens focuses and zooms (if it does) is an important consideration when using some of the filters covered in this book. Before autofocus and the availability of high-quality zoom lenses, lenses were mechanically simple. To focus, a ring on the barrel of the lens moved a group of elements inside, focusing the light being captured onto the film plane. Early zoom lenses required a simple push/pull or twist to move a group of elements to change the focal length. Usually, none of these actions caused the front of the lens barrel to rotate. While it differs from lens to lens, the front of the lens often rotates when the lens is focused or zoomed with newer lenses. Some autofocus zooms rotate the front when zooming but not focusing; others rotate the front when focusing but not zooming. With many spe-

cial effect and all polarizing filters, the rotation of the front of the lens has a direct effect on how images are captured. With such lenses, it's important to compose and focus before aligning the filter.

Meters. Through-the-lens meters built into cameras can sometimes be fooled when strongly-colored filters are used. It's a good idea to have a handheld exposure meter along, and to be familiar with its operation. Metering will be covered in considerable detail later on in this book.

Tripods. Finally, a good-quality tripod is important for optimum results. The loss of light resulting from the use of filters will require longer than normal exposures. A tripod eliminates the most common problem in photography—blurred images due to camera movement.

Some photographers wonder why they should bother with filters when the photo is being taken, since the image can be brought into a computer and modified with an image-editing program. There are many cor-

rections that can be made in the computer, including many things that can't be done when taking the picture. But, the reality is, even supposedly similar effects in the camera and on the computer will produce different results. The truth of the matter is that each method has its own uses and its own requirements. For example, no amount of unsharp masking or any set of computer plug-in filters will provide the range of soft-focus effects that can be achieved by lens filters.

● FILTERS AND DIGITAL IMAGING

Most of the filters discussed here will work with both film and digital cameras. However, there are certain points that you should keep in mind if you choose to use the filters discussed in this book on a digital camera. For one thing, many of the consumer digitals don't have standard threaded lens barrels, so they can't readily accept most filters. You should also note that some of the more subtle filter effects are lost when images are captured digitally.

● FILTER BRANDS

Most of the filters mentioned in this book have been tested. Where possible, references to specific product information (including the type, name and, with unique filters, the manufacturer's name) has been provided to help the reader locate the same/similar filters in stores. None of this information should be taken as an endorsement of any specific filter brand. Other manufacturers may have similar filters that work equally well.

FACING PAGE: Filters allow the photographer to express his or her interpretation of a scene. Here, a Lee Enhancing filter was used to increase the red in the rocks and a two-stop neutral-density graduated to darken the sky and draw attention to the rock formation.

Filter types discussed in this book are named by their common nomenclature in the United States. Where appropriate, specific filters are designated by their Kodak Wratten designation, a naming convention accepted worldwide.

Understanding how filters work can teach a great deal about photography to both beginners and experienced photographers. Filters, in effect, make it possible for photographers to take control of the creative process.

CHAPTER 1

LIGHT
AND
FILTERS

Photography is, by its nature, part art and part science. This is just one of the many dualities in photography. Technological advances in both camera and film design have made it easier to take photographs by masking many of the complexities of the technology involved.

With the sophisticated automatic cameras available today, just about anyone can take a technically correct photograph. Still, a basic understanding of light and how it relates to the final image recorded on film is essential to understanding how filters work.

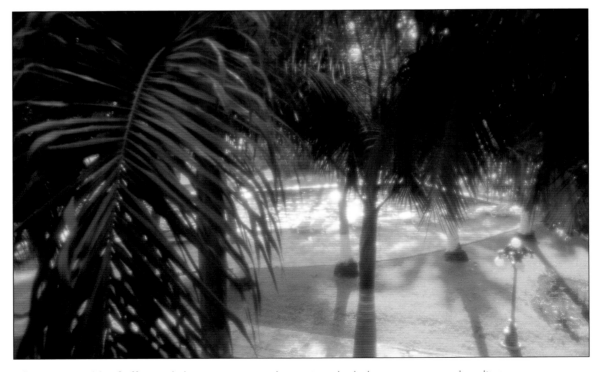

Filters are capable of affecting light in many ways, altering its color balance, contrast and quality.

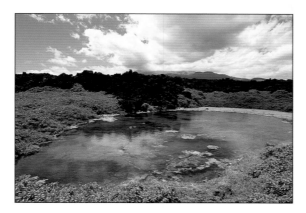

In many scenes, the range of brightness exceeds the ability of the film to capture detail in both the highlights and the shadows. If filters are not used, the photographer must choose between detail in shadow areas (top) or detail in highlight areas (bottom).

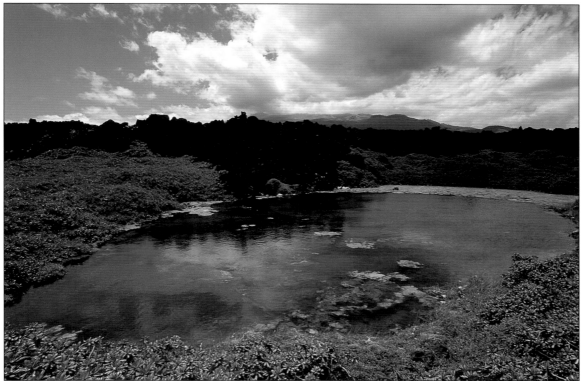

The characteristic of the light falling on a subject is one of the primary factors in determining how a subject will be recorded. These characteristics include the size of the light (for example, a small spotlight or a diffuse overcast sky), the direction of the light (from the side, directly overhead or from the back) and the color temperature of the light (such as "warm," or reddish, sunset light or "cool," or bluish, predawn light).

Portrait and commercial photographers working in a photo studio are fortunate to have complete control over each of these characteristics. Outside of the studio, the ability of the photographer to control these characteristics is far more limited. In both cases, however, understanding these characteristics and how they relate to the subject is essential to understanding the role filters can play.

LIGHTING CONTRAST

The overall contrast of a photograph is a measure of the amount of difference between the highlight and the shadow values. The size of the light source illuminating the subject is the primary determining factor of the overall contrast in the photo. A small light source, like a spotlight, or a large light source far from the subject, like the sun, creates a scene with high contrast. An extended light source, like the sky on a heavily overcast day, produces low scene contrast.

Changing the light source or modifying its intensity impacts image contrast. However, changing the light source or intensity isn't always possible, or even desirable, in a particular situation. That's where filters come in. There are filters available to both increase and decrease overall contrast of a scene.

Besides overall image contrast, there's also local contrast, which is the contrast between different elements in proximity to each other within the composition. It's possible to have low local contrast within a composition that has a high overall contrast. For example, a shaft of sunlight striking the ground deep in the forest provides high overall contrast, yet the ferns in the shadowed foreground covering the forest floor have low local contrast. Filters provide a way of dealing with such situations, whether the final photos are in black & white or color.

LIGHT DIRECTION

The angle between the subject and the light source also influences contrast, particularly when small light sources are involved. When the angle is small, when the light source is directly behind the photographer, or when the angle is 180°, and the subject is backlit, the local contrast is generally low. It's interesting to note that in the first case, the overall contrast is also usually low and the lighting is termed "flat." In the second case, that of backlighting, while the local contrast is low, the overall contrast can be quite high.

As the angle between the light source and the subject increases from 0 to 90°, the local contrast increases. From 90 to 180° it decreases again, as the light moves behind the subject. It is wise to consider the light direction and the effect it will have on a photo, both for technical and aesthetic reasons.

Photographers working outside of the studio have only marginal control over the direction of the light source. Fashion and glamour photographers frequently wait for that "golden hour" just before sunset, when the angle of light is low on the horizon. Sometimes photographers can wait for the lighting condition to change, such as waiting for cloud cover or partial sun. At other times, they can adjust the position of the subject to find the optimum light angle. And they can add fill light from various directions, either through reflectors or electronic light sources.

THE "TEMPERATURE" OF LIGHT

When we see a photograph taken at sunset, we say it looks "warm," because the predominant colors of sunlight at that time of day are red, orange and yellow. Visible light, the light to which our eyes respond, is made up of these colors as well as green and blue.

ELECTROMAGNETIC SPECTRUM

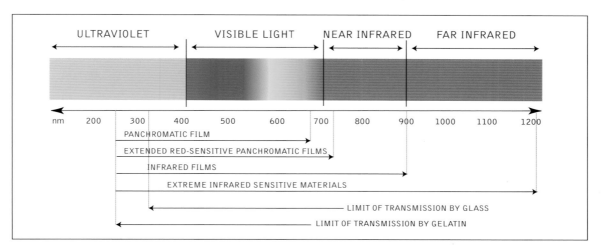

In the seventeenth century, Sir Isaac Newton demonstrated that when daylight passes through a prism, it is broken up into a series of colors—red, orange, yellow, green, blue and violet. These are known as the chromatic colors. Those colors that are not a component of daylight, such as tan or burgundy, are known as non-chromatic colors.

Visible light makes up a small portion of the electromagnetic spectrum, as illustrated above.

What we call "white" light is light containing roughly equal amounts of each chromatic color. This is the "daylight" for which daylight-type color film is balanced. But, in reality, daylight isn't the same on all points of the globe. The color of daylight changes from point to point on the globe, from one time to another during the day and from season to season. Modern color films are balanced for the "daylight" that is approximately the color of sunlight in the northern latitudes at noontime during the summer on a clear day.

Visible light that contains a greater proportion of the red end of the spectrum is considered "warm" light and, conversely, light containing a greater portion of the blue end of the spectrum is considered "cool." These subjective impressions of color have been quantified for photography by means of the Kelvin temperature scale, a measure used by scientists to indicate the temperature to which a theoretical "blackbody" must be heated in order to radiate light of a specific hue (wavelength or combination of wavelengths).

This scale allows the assignment of a color temperature, expressed in degrees Kelvin, to various sources of continuous light, including sunlight, at different times of the day. Color temperatures can be measured with a color temperature meter, which is an essential piece of equipment for any serious photographer. Using a color temperature meter allows the photographer to either maintain a perfectly neutral color balance or shift the color balance of a scene in a predictable way.

KELVIN TEMPERATURE OF SELECTED LIGHT SOURCES

Source	Color Temperature (K)
Cloudless blue sky	12,000 to 18,000
Overcast sky	6000 to 8000
Average sunlight (two hours before and after noon)	5400
Photographic daylight	5500
Electronic flash (professional studio, bare tube)	5400 to 6400
Electronic flash (professional studio, in softbox)	4850 to 5950
Built-in or on-camera flash	5500 to 6500
HMI (halogen metal halide) bulb	5500 to 6000
500w Photoflood bulb	3400
Quartz-halogen bulb	3200
200w household incandescent bulb	2980
100w household incandescent bulb	2900
75w household incandescent bulb	2820
40w household incandescent bulb	2650

The above table gives the color temperature of various light sources. The "warmer" the light source, the lower its color temperature.

● ADDITIVE COLORS

The eye, however, does not act like a color temperature meter, which is sensitive to all wavelengths of the visible spectrum. To oversimplify somewhat, cone cells in the eye are sensitive only to red, green and blue light. Thus, the eye can be "tricked" into giving the same response, in terms of color, to different stimuli. For example, the eye will perceive a light as being yellow if it in fact contains the wavelengths corresponding to yellow, or if the light is composed of red and green components (and no yellow component) of proper intensity.

The proper mixing of red, green and blue light in the eye can duplicate any color sensation. If equal intensities of these colors are added together, the eye perceives the light as white light. For this reason, red, green and blue (or RGB) are known as the additive primaries.

This same sensation of white light can be achieved by mixing together light of two pure colors such as certain yellows and blues, reds and blue-greens or greens and magentas. These colors are known as complementary colors, and they play an important role in creating color contrast in photography.

In a famous experiment, Edwin Herbert Land, inventor of the Polaroid camera and founder of Polaroid Corporation, showed that color vision depended on the eye receiving the proper stimulus from only a few wavelengths of light, not on the presence of a full spectrum. He photographed a scene twice using panchromatic (sensitive to all wavelengths of visible light) black & white

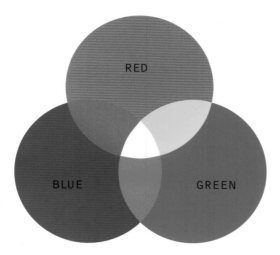

Additive primary colors red, green and blue. Equal amounts of additive primary colors produce white.

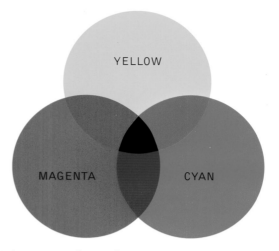

Subtractive colors yellow, cyan and magenta. Equal amounts of subtractive colors produce black.

film. The first photo was taken using only magenta light. The second used only green light for illumination. When the films were projected together on the same screen, one in a projector fitted with a magenta filter and the other in a projector fitted with a green, a full-color image was created. The same full-color image was also created when white light was used in one of the projectors!

There are also subtractive primaries. These are colors that are created by combining equal amounts of the additive primaries. These colors are magenta (red and blue combined), yellow (red and green combined) and cyan (blue and green combined). Along with black, the subtractive primaries are the colors of the inks used in the printing process to reproduce color photos in newspapers, magazines and books. See the figures at the top of this page.

An additive primary (for example, red) is complementary to its corresponding subtractive primary (cyan) as well as to the col-

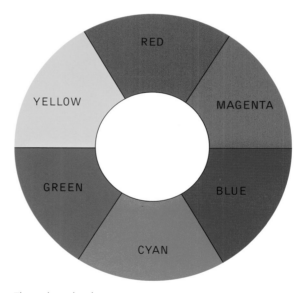

The color wheel.

ors that make up the subtractive primary (blue and green). Reviewing the color wheel, shown above, makes this concept a little easier to follow.

Along the same lines, subtractive primaries are complementary to their additive primaries and the colors that make them up. The color wheel illustrates the interrelationship.

A truncated white paper cone is placed on a white background and lit by a spotlight filtered by the additive primary red.

The same cone is lit by another spotlight, 120° from the first, filtered by the additive primary green.

A third spotlight, 120° from the other two, is used to illuminate the cone with the additive primary blue.

When two of the additive primaries illuminate the cone simultaneously, in this instance red and green, the subtractive primary yellow is formed where they mix. Inside the cone, where there is no mixing, the additive primaries remain pure. Yellow is the subtractive primary to blue, the additive primary not illuminating (subtracted from) the cone.

Similarly, when the additive primaries red and blue illuminate the cone, the subtractive primary magenta is formed where they mix.

Illuminating the cone with blue and green additive primaries produces the subtractive primary cyan.

When all three of the additive primary colors (red, green and blue) illuminate the cone simultaneously, a spectrum of additive and subtractive primaries can be seen on its surface. In the center of the cone the additive primaries appear where they have not mixed together. Opposite the additive primaries, on the surface beyond the cone, are crescent shapes of their corresponding subtractive primary. Areas of the background covered by all three additive primaries are not white as they should be because the filters used do not produce pure color.

Red is complementary to (opposite) cyan, and is also complementary to the colors that make cyan, blue and green. Blue is complementary to yellow and to red and green, which make yellow. Green is complementary to magenta and to blue and red, the components of magenta.

● BASIC COLOR THEORY
The accompanying photographs visually demonstrate the relationship between the additive and subtractive primaries and the color spectrum.

The relationship between the different types of colors may be a little difficult to follow, but understanding that relationship is essential to understanding how filters work because *color filters have their strongest effect on their complementary colors and the colors that make them up.* This is true for both color and black & white films.

ABSORPTION OF LIGHT

The colors we see are a result of the partial absorption of light by an object. When white light falls on the object, various pigments in the object absorb a portion of the spectrum. The wavelengths reflected back (or transmitted) produce the sensation of color to our eyes. Thus, a green leaf contains pigments that absorb all colors of the visible spectrum except green, which is reflected back. Similarly, a sheet of red cellophane (or a red photographic filter) contains pigments that absorb all colors of the spectrum except red, which is transmitted.

Understanding this relationship is essential to understanding how filters work. *Filters do not add color to a scene; they can only absorb colors that are present.* Thus, a color photo taken through a red filter appears red not because the filter added red to the visible light, but because it absorbed other colors and transmitted only the red portion of the white light. This is actually illustrated a little better with black & white film than with color photography. When using a red filter with black & white film, the film records a green leaf as nearly black because the leaf has absorbed nearly the entire red component of the visible light and the red filter absorbs the rest of the light, which is primarily green, reflected by the leaf.

PHOTOGRAPHIC FILM

With only a few exceptions, photographic film is manufactured so that it is sensitive to all colors of the visible spectrum. This is true of black & white emulsions that render colors in terms of gray values, color transparency films that produce a positive rendition of a scene and color negative films that must be printed onto photographic paper to yield a positive image.

With the notable exception of Kodachrome, modern color films are coated with three (or more) light-sensitive emulsion layers: typically cyan, yellow and magenta. Each of these layers respond to only one color of light and is coupled with a dye layer that, during color development, produces the actual color seen. Associated with each of these dye layers is a filter layer that removes the wavelengths to which their corresponding dye layer is sensitive.

Color films, both negative and transparency, are balanced to produce a neutral recording

Absorption/reflection of sunlight from a green leaf.

Transmission of red cellophane.

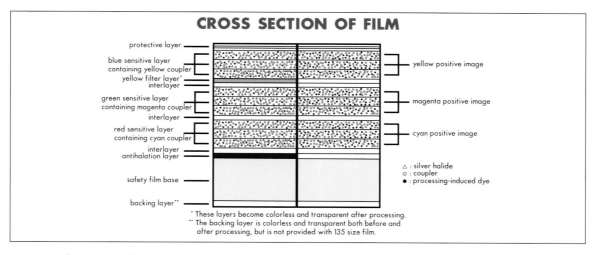

CROSS SECTION OF FILM

protective layer

blue sensitive layer containing yellow coupler — yellow positive image

yellow filter layer*

interlayer

green sensitive layer containing magenta coupler — magenta positive image

interlayer

red sensitive layer containing cyan coupler — cyan positive image

interlayer

antihalation layer

△ : silver halide
○ : coupler
● : processing-induced dye

safety film base

backing layer**

* These layers become colorless and transparent after processing.
** The backing layer is colorless and transparent both before and after processing, but is not provided with 135 size film.

Courtesy of Fuji Photo Film Co., Ltd.

of a neutral subject, such as a gray card, with a specific color temperature light shining on the subject. In the case of daylight-balanced films, the color temperature is 5500° Kelvin (5500K), or approximately that of noontime sun and electronic flash. Tungsten (Type B) films are balanced for 3200K sources such as quartz-halogen lamps.

Black & white films are not rated by color temperature although they do respond differently to sources of different color temperatures. Films of varying emulsion speeds or of the same speed from different manufacturers do not respond in the same way to filters. Even the same film with the same filter will respond differently if the light source is tungsten rather than daylight. For critical use, film, filter and, in the case of black & white, developer combinations should be tested.

Because color negative film must be printed onto photographic paper to yield a positive image, a skilled color printer can do an enormous amount of color correcting. Daylight-balanced film exposed under most non-daylight lighting conditions can be corrected back to natural colors, and likewise with tungsten-balanced emulsions. For this reason, and because there is no clue in the film as to the photographer's intent as far as color rendition, color negative film is not the best choice when using filters to achieve specific color effects. However, this problem can be minimized if a gray card is exposed as the first frame on the roll and the lab is instructed to balance to the gray card, printing the rest of the roll with the same color settings, varying only the exposure if necessary. This technique is also necessary when ordering PhotoCD scans of filtered color negatives and transparencies.

Color transparency film most directly reproduces the effect of filters and is the type of film recommended for the serious photographer who is not doing his or her own color printing.

Transparency film is the most sensitive to color temperature variations as well as expo-

sure errors. For these reasons, meters are an essential part of the photographer's arsenal of equipment.

● DIGITAL CAMERAS

Before looking at meters, we'd like to offer a few words about using filters on digital cameras. While much of the information in this book applies to both film and digital photography, the digital camera, like the film camera, must be capable, in many cases, of being adjusted manually. Use of some filters will seriously impede autofocus and auto-exposure systems in either type of camera.

In digital photography, setting the "white point," the point of neutral balance where "white" is rendered without color cast, either automatically or manually, corresponds to selecting daylight or tungsten bal-

anced film. If white balance is automatic each time an exposure is made, the camera will do its best to "correct" the effect of a color filter over the lens. Only digital cameras that allow the white balance to be set and locked prior to attaching the filter are usable for serious filter photography.

Aside from the usual difficulty of viewing the LCD preview in non-SLR digital cameras, using filters with them parallels using filters with film cameras.

● METERS

While many modern cameras have sophisticated built-in metering systems, handheld meters are helpful in many cases and essential in some cases when using filters.

Because many filters work by absorbing a portion of the visible spectrum, less light is

By varying the exposure, here ²/₃ of a stop above and below the metered exposure, the same filter gives different treatments to the subject.

F-STOP INCREASE REQUIRED FOR FILTER FACTORS

Filter Factor	Exposure Increase (Stops)
1	0
1.2	$\frac{1}{3}$
1.4	$\frac{1}{2}$
1.5	$\frac{2}{3}$
2	1
2.5	$1\frac{1}{3}$
2.8	$1\frac{1}{2}$
3	$1\frac{2}{3}$
4	2
5	$2\frac{1}{3}$
6	$2\frac{2}{3}$
8	3
10	$3\frac{1}{3}$
12	$3\frac{1}{2}$
16	4
32	5
64	6

available to the film, so exposure must be increased when filters are used. This exposure increase is called the "filter factor" and can range from $\frac{1}{3}$ of a stop to three stops or more for some filters. The above table gives the f-stop adjustments for common filter factors. As various filters are covered in this book, their filter factors are given for reference.

It should be noted that when two or more filters are used simultaneously, there is an exponential increase in exposure time. The individual factors for the different filters are multiplied rather than added to obtain the final exposure correction. The table above shows that a filter with a filter factor of "1" requires no increase in exposure. If another filter with a filter factor of "4" is added, the exposure increase is only the two stops required by the second filter (4 x 1 = 4), not $2\frac{1}{3}$ stops, as it would be if the filter factors were added (4 + 1 = 5). Similarly, two filters with filter factors of "4" require a 16x increase in exposure, not 8x. As exposure times increase with filter use, a tripod becomes an essential piece of gear for the photographer.

In some cases, the metering system built into the camera can adjust for the filter factor. This is truer with lighter-colored filters in color photography than with the denser filters used in black & white. In-camera meters are least accurate when using the special effect filters (discussed in chapter 5) or when the scene contains a large proportion of the color that is being filtered out.

For example, if a red filter is being used for a black & white photo at the beach where the scene is made up of predominately blue water and blue sky, metering through the lens with the filter in place will likely produce massive underexposure since the filter is removing the blue components of the scene. In this and similar cases, it is best to meter without the filter, apply the filter factor and set the adjusted exposure manually.

An incident light meter is useful in a large number of situations. It's particularly useful if an accessory reflected light spot-metering attachment can be fitted. Some meters have the spot-metering attachment built into the incident meter. Spot meters allow the measurement of small areas of the scene, which is useful when trying to determine, for instance, how much brighter the sunset sky is than the foreground subject. Many sophis-

A separate light meter is a useful accessory when using filters because the meter built into the camera may not respond accurately, or give any reading at all, when certain filters are used over the lens. An incident light meter (top, left) measures the light falling on the subject. This particular model accepts a five-degree spot-metering attachment (top center) that can be used to measure light reflected from the subject or from clouds in the sky. Some meters, like this model from Sekonic (top right), have a variable spot meter built into an incident meter, and can be used to measure electronic flash as well. The human eye is a poor judge of color temperature. Color temperature meters, like this Minolta model shown on the left, are needed to provide information about the color quality of the incident light. Once this information is known, the color temperature can be changed predictably and repeatedly with filters.

ticated meters also allow for the metering of electronic flash, which is useful in studio situations. The above photographs illustrate the types of meters available.

When using these meters, there are several ways to adjust for the light loss of the filter that will be used over the camera lens. After taking an incident or reflected light reading, use the filter factor to calculate the amount the aperture must be opened up or the shutter speed increased, then set the camera manually.

A simpler method is to adjust the ISO setting of the meter before making the reading. Simply divide the speed at which film is to be shot (for example, Kodak 100S at ISO 100) by the filter factor (let's say it's two), and set the ISO on the meter to the appropriate number, in this case, fifty. The shutter speed and aperture reading can then be read directly from the meter and transferred to the camera with no further adjustment required. Remember to adjust the ISO for each filter used, and to adjust it back again when no filter is being used.

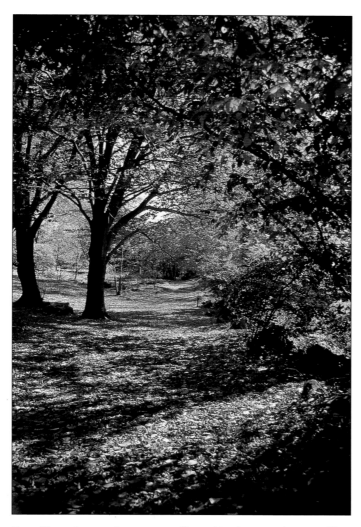

Even filters that produce strong effects, like the Lee Enhancing filter used here, can produce natural-looking images if the photographer understands how filters work. (photo by Amelia Sholik)

Two-color meters work only with light sources that emit a continuous spectrum of light, such as the sun or an incandescent bulb. Three-color meters work with continuous spectrum sources as well as with some discontinuous sources, such as fluorescent lights.

Architectural interior photographers rely heavily on three-color meters for their work. Often each light source in an interior shot must be exposed separately, with the proper correction filter determined by use of the color temperature meter, in order to render the scene as the eye sees it.

There are times when the photographer may want to render the scene warmer or cooler than neutral for aesthetic reasons. In these cases, the color temperature meter is used to determine a filter to render the scene neutral and then a filter pack (a specific combination of filters) is calculated to provide a predictable amount of color shift.

As mentioned earlier, when it is necessary to shift the color balance of a scene in a predictable way, a color temperature meter, such as the one shown on page 26, is essential. Although this type of meter tends to be expensive, it gives the photographer greater control over the color balance in the image.

There are two types of color temperature meters—two-color and three-color meters.

Studio photographers rely on color temperature meters to measure the color temperature of electronic flash heads. They can then add filtration to each head or softbox diffuser so that the light emitted by each will be of the same color temperature. Then, if necessary, filters are added to the camera lens to balance the lights, yielding a neutral rendition on film.

While color temperature meters take some time to calibrate and some experience to use successfully, they make it possible to predictably control the use of color in a variety of situations and shooting conditions.

● FILTER MATERIALS

All filters are not created equal! When you shop for filters, keep in mind that a specific filter type may be offered at a wide range of price points. While higher quality professional filters generally cost more than mass-produced consumer filters, price alone shouldn't be the deciding factor when selecting from a number of supposedly similar filters. At times the least expensive filter, rather than the most expensive one, may be the correct choice. At other times nothing but the best should be considered. Owning a variety of filters can require a sizable investment; therefore, knowing something about the types of materials from which filters are manufactured is important for making the right choices.

Filters are manufactured from four types of material: gelatin, polyester, resin and glass. Each has its advantages and disadvantages, and there are variations in quality within each type and between manufacturers.

By far, the greatest range of filters is available in gelatin. Gelatin filters have been available for so long and in so many varieties that the term "gel" has become synonymous with "filter." Gelatin filters are made by dissolving precisely formulated dyes in liquid gelatin and coating the solution onto prepared sheets of glass. After the coating is dry, the gelatin film is stripped from the glass, coated with lacquer and cut to size. Prepared in this manner, gelatin filters have a thickness of 0.1mm plus or minus 0.01mm. Because of their uniform thickness and the precision of the manufacturing process, gelatin filters are least likely to degrade image quality—at least while they're still new.

Unfortunately, gelatin filters require the greatest care in storage and handling. The thin lacquer coating offers only limited protection, so they must be handled extremely carefully by the corners or the edges. They also must be cleaned carefully. Dust and dirt particles should only be removed by blowing clean, dry air from an aerosol can across the surface of the filter. Any remaining particles should be gently removed using a dry, clean camel's-hair brush. Wiping with a cloth will cause tiny scratches that degrade image quality.

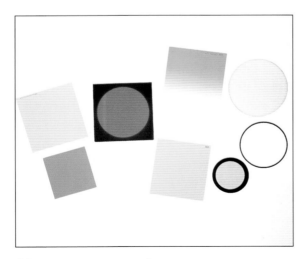

Filters are made from four materials: gelatin, polyester, resin and glass, shown left to right. Gelatin filters are available in 75mm and 100mm squares. Polyester filters, shown in a cardboard mount for increased durability, are made in the same two sizes. Resin filters are generally designed as part of a system, often with a proprietary size, and may be square or rectangular. Glass filters come in a variety of sizes to mount directly onto the lens or, for some large-format cameras, behind the lens.

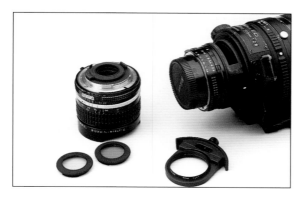

While most lenses use filters mounted on the front, some specialized lenses, like this Nikkor fisheye and 300mm f2.8, take filters that either screw into or drop into the rear of the lens.

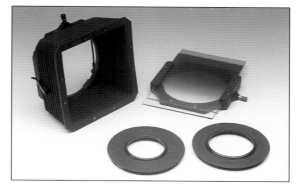

Lee Filters offers a complete filter system consisting of a wide range of filters, modular filter holders, lens shade and adapter rings for mounting on different diameter lenses. The gradated background was created with a Cokin 123 Blue 2 graduated filter.

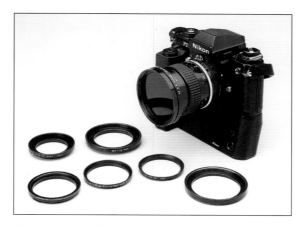

Step-up rings and step-down rings can be used to adapt round filters of one size for use on a lens that requires a different size. Care must be taken that the adapter or the filter does not intrude into the field of view of the lens, causing vignetting.

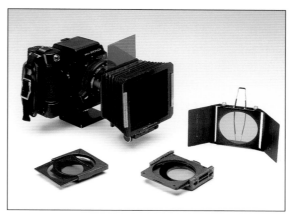

There are many gelatin filter frames and holders on the market. Some professional lens shades like this one made by Bronica, called compendiums, have a slot at the back to hold unmounted gels. Other holders clamp or screw onto the lens. The background in this photo was achieved with a Cokin 124 Tobacco 1 graduated filter.

When not in use, gelatin filters should be stored in a dry, cool environment, in their original packaging. High humidity can cloud the gelatin. Even under ideal storage conditions, the dyes, like all dyes, can change over time. Gelatin filters that are used frequently need to be replaced periodically.

Gels are sold unmounted in 75mm (about 3 inches) and 100mm (about 4 inches) squares, and require a frame and holder for mounting in front of the lens. There are many frames and holders on the market, as shown above.

Some manufacturers eliminate the handling and storage problems of gelatin filters by creating a sandwich of the gel between two pieces of glass. This combines the precision of the gelatin filter with the ruggedness of a

glass filter. When carefully manufactured with clear, high quality glass and properly sealed against moisture, this type of filter is an excellent choice, though considerably more expensive than the pure gelatin filter. All glass-polarizing filters are made this way.

Filters made from high-quality polyester-base materials to which dyes have been added are rapidly replacing gelatin-based filters for all but the most precise scientific applications. Polyester filters are available in a wide range of types at reasonable cost. They are tough, impervious to moisture and easy to clean, though care should still be taken to blow off dust with canned air as a first step in any cleaning process. Like gels, polyester filters are usually sold unmounted in 75mm or 100mm squares, so they also require frames and holders for use.

Acrylic resin filters were first popularized as special effect filters in the 1970s, but have since grown into a wide range of filter types from numerous manufacturers. Unlike gelatin and polyester filters, resin filters do not need to be one solid color, but can be manufactured with clear areas graduating to color, or one color graduating into another, or with many other characteristics.

Resin filters can take much rougher treatment than gelatin or polyester, yet are lightweight for their size. Given the same care as camera lenses, these filters will last for years.

Sizes of the square or rectangular resin filters vary from manufacturer to manufacturer. They're generally designed as part of a system, which includes an adapter ring for mounting the filter holder onto the camera

Photographers who own a number of lenses with different front diameters can buy adapters for each lens. The adapters connect to one filter holder, which can hold gelatin, polyester or resin filters. It would otherwise be necessary to buy the same screw-in glass filter in the proper diameter for each lens. The gradated background was created with a Cokin 121 Gray 2 graduated filter.

lens, the filter holder and a lens shade. Because the thickness of the filters from different manufacturers varies, filters from one company are generally not usable in a competitor's holder.

As a group, gelatin, polyester and resin filters have one significant advantage over glass filters if they are to be used on a number of lenses with different filter sizes. Since these filters require an adapter to mount the filter holder to the lens, it is only necessary to buy different adapters for different lenses rather than duplicate sets of screw-in glass filters for different diameter lenses. That can result in tremendous savings, not only in cost but also in weight. Filter adapters come in a wide range of diameters, matching virtually any lens that's available.

High-quality glass filters produce the highest quality images. While this would most

likely never be seen in enlargements smaller than 11x14 inches, and the difference is likely small even then, there is a difference. There are several reasons for this.

Glass filters, other than the least expensive ones, are made from optically clear glass (called water glass) that has been dyed while molten, then cooled and cut into cylinders. The glass is ground with both surfaces per-fectly parallel to one another and mounted in a mounting ring that accurately aligns the filter surface parallel to the front lens element. The finer glass filters have antireflec-tion coatings like quality lenses.

Antireflection coatings eliminate the ghost-ing and flare seen in photos with strong backlighting or where there is a bright light source at the edge of the frame. Uncoated

When using a sunset filter like the Lee Sunset Red used here, it is important that the sun is in a position so that shad-ows in the scene look like the sun is low in the sky. The large size of the Lee line of graduated filters allows them to be used on very wide-angle lenses, such as the 20mm used here, without vignetting.

glass filters transmit only 92% of the light that enters them. Resin filters transmit even less. Some of the lost light is refracted and reflected on the surfaces of the glass, reducing contrast and causing ghost images.

A single layer of antireflection coating lowers the amount of non-image-forming light by half. Multiple layers allow for the transmission of as much as 99.7% of the incident light, allowing only 0.3% to be available to reduce image quality. Interestingly, the most important surface for multicoating is the final surface of the filter, the one closest to the first element of the camera lens. Some manufacturers multicoat only this surface, with a single coating on the surface facing the scene, while others multicoat both surfaces. Expect to pay significantly more for multicoated filters.

While some multicoated filters also have a final anti-scratch coating, care must still be taken when cleaning them. Clean, dry canned air will remove loose particles, and should be followed by a light brushing with a camel-hair brush. A gentle wipe with a soft lens tissue or one of the new microfiber cleaning cloths will remove any stubborn dirt. Lens cleaning solutions should not be used on these filters (or on multicoated lenses) as they may damage the coating by creating permanent streaks on the glass surface.

FACING PAGE: If the filter intrudes into the field of view of the lens as shown here, the corners of the frame will appear dark. This effect, called vignetting, occurs most often with filters on wide-angle lenses. Using a thinner filter or an adapter with a larger filter will eliminate the problem.

Multicoated glass filters are a good idea if the filter will be on the lens all the time, such as a UV (ultraviolet light reducing filter) or skylight (ultraviolet-reducing and warming filter). Glass filters, except for some polarizers and some extremely thin designs made for extreme wide-angle lenses, have a screw thread on the mount, allowing for the attachment of additional filters, or the appropriate lens shade.

While it is possible to buy one glass filter with a diameter that is large enough for the largest diameter lens and carry adapters to "step up" the smaller diameter lenses to fit that filter, this can cause vignetting, a darkening or even a black circle in the photo, caused by the filter extending into the field of view.

● LENS SHADES

Adding filters in front of the lens increases the possibility of lens flare from light outside of the angle of view of the lens. Using a lens shade (or hood) minimizes flare. Even multicoated lenses can benefit from the use of lens shades.

Shades supplied by lens manufacturers are designed to end just outside of the lens field of view. Adding a filter or two and then replacing the lens shade can lead to vignetting, visible at the edges of the photo as a dark circle.

Vignetting can be eliminated with gelatin, polyester and resin filters by using an adjustable lens shade, also known as a compendium, with rear slots to hold the filters. These are available from a number of manufacturers.

Also available are compendium lens shades that attach to the tripod socket or incorporate a camera grip rather than attaching to the front of the lens. These eliminate the problem of having the filter holder attached to a lens with a front section that rotates. Many of these compendiums have slots where square or rectangular filters can be inserted.

With glass filters, a shade designed for a slightly shorter focal length than the lens in use can be used if it has the correct diameter to screw into the filter. Otherwise it is possible to buy aftermarket lens shades of different depths, depending on the lens's focal length and filter mount size.

The next chapter will cover how filters can be used to enhance black & white photography. Photographers with no interest in black & white photography are encouraged to still read the chapter carefully, because many of the principles discussed apply also to color photography.

FACING PAGE: Day-for-night effects can be created by using a 23A and 58 filter in combination with black & white panchromatic film. Exposure depends on the lighting conditions as well as the developer. A filter factor of 16, used here, is a good starting point with Ilford HP5 Plus developed normally in D-76. It is a good idea to bracket at least a stop in each direction around the calculated exposure in half-stop increments.

CHAPTER 2

FILTERS FOR BLACK & WHITE PHOTOGRAPHY

For a photographer who has little experience working in black & white, it may seem odd that, in order to create a visually accurate black & white photograph, it is necessary to think in terms of color. But this is indeed the case. The majority of black & white films currently on the market, including Kodak's Plus-X, Tri-X and T-Max family, Ilford's FP-4 and HP-5, Fuji's Neopans and Agfa's Agfapans, are panchromatic emulsions, that is, they are manufactured so that they are sensitive to the colors of the entire visible spectrum.

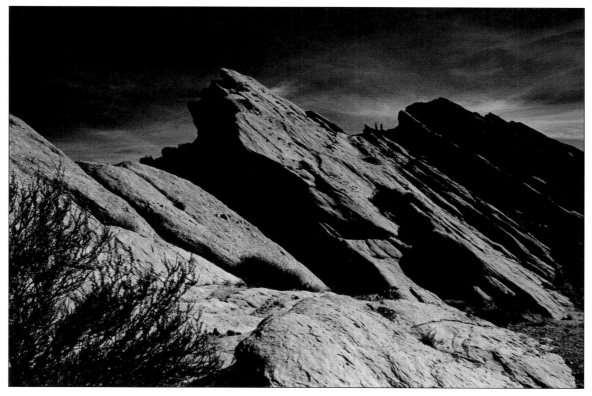

Panchromatic films are designed to translate, as closely as possible, the color world of our experience into corresponding tones of gray. In most cases, this process works remarkably well, but on closer examination, deficiencies in the representation of color in shades of gray become obvious. While the film is sensitive to all colors, it is not sensitive to all colors in equal amounts. And, most importantly, it is sensitive to wavelengths in the far blue and ultraviolet range of the spectrum to which the human eye is insensitive. This can have a direct impact on the final black & white image.

The primary role of filters in black & white photography is to correct for the deficiencies in the way film translates color into tones of gray. But this is not their only role.

Filters can also provide separation of gray values where they do not occur in nature. For instance, panchromatic film is about equally sensitive to red and green light. So a bright red apple and a light green apple, which are quite different when seen in color, are recorded in black & white as very similar values of gray. No amount of darkroom manipulation, either in film processing or in printing, will significantly change this.

The Zone System (applied during film exposure and processing), and variable contrast printing along with "burning" and "dodging" (applied during printing) can have a dramatic effect on overall contrast and highlight/shadow values. However, none of these techniques have much impact on midtone gray values. To adjust midtone values, filters are required.

Once the role of filters in black & white photography is understood, they can also be used to "overcorrect" a scene for dramatic effect. Finally, certain filters are required when shooting black & white infrared film.

● TRANSLATING COLOR ACCURATELY INTO TONES OF GRAY

Understanding that panchromatic film has certain shortcomings, you may ask yourself, how can filters be used to minimize them? The answer is, by applying the relationship learned in chapter 1—that color filters transmit light that is the color of the filter and selectively absorb other colors, with the greatest absorption occurring in wavelengths that are complementary to the filter color. In black & white, this means that the film will receive more exposure from colors similar to the color of the filter and less exposure from complementary colors. In the final print, tones with the greater exposure will reproduce lighter than tones in which exposure has been decreased.

Since panchromatic film tends to be overly sensitive to the blue end of the spectrum, this can be corrected by using the filter that is complementary to blue, i.e., a yellow filter. There are a number of yellow filters available of different strengths. These allow the photographer the ability to control how much of the blue will be absorbed. These yellow filters are commonly used to darken blue skies in black & white landscape photography.

Yellow filters are not the only ones that will darken blue. Although yellow is complementary to blue, remember that filters will not only darken their complement, they will

darken the components of their complement. Blue and green are components of cyan, whose complementary color is red. So the blue sky could also be darkened by adding a red filter, which would also darken the green in the scene. Because of the dramatic effect that they have on the final image, red filters are popular in architectural and landscape photography.

Similarly, blue and red are components of magenta, whose complementary color is green. Again, the blue sky could be darkened with a green filter, which would also darken any magenta in the scene. The chart on page 38 shows filters commonly used for black & white photography, along with their approximate filter factors and their common use. Filter factors are different for daylight (including electronic flash) and tungsten sources because of the different amounts of the additive primary colors in these sources.

Different types of black & white film respond differently to these filters also. The table shown below gives the filter factors recommended by manufacturers for common black & white emulsions and filters. It is best to meter the scene before adding the filter to the lens (or, better yet, to determine the exposure with a handheld meter), then apply the filter factor and set the camera manually, as explained earlier.

These black & white filters are very strongly colored. They're not generally recommended for use with color film, since they would put a strong overall color cast on the final image. Color casts aren't appropriate for most general types of photography, but they can be used for special effect in certain

Filter Corrections for Black & White Films								
Wratten Filter Number	**Plus-X**		**Tri-X**		**T-Max 100**		**FP4 Plus**	
	Daylight Filter Factor	Tungsten Filter Factor	Daylight Filter Factor	Tungsten Filter Factor	Daylight Filter Factor	Tungsten Filter Factor	Daylight Filter Factor	Tungsten Filter Factor
8	2	1.5	2	1.5	1.5	1.2	1.5	1.2
11	4	4	4	3	3	3	3	3
15	2.5	1.5	2.5	1.5	2	1.5	2	1.5
25	6	4	8	5	8	4	6	4
47	6	12	6	12	8	25	6	13
58	8	8	6	6	6	6	6	6

Wratten Filter Number	**HP5 Plus**		**100 Delta**		**400 Delta**	
	Daylight Filter Factor	Tungsten Filter Factor	Daylight Filter Factor	Tungsten Filter Factor	Daylight Filter Factor	Tungsten Filter Factor
8	1.5	1.2	1.5	1.2	1.5	1.2
11	3	3	3	3	3	3
15	1.5	1.5	2	1.5	1.5	1.5
25	6	4	8	4	6	4
47	6	6	8	25	6	6
58	10	19	6	6	10	19

FILTERS FOR BLACK & WHITE FILMS

Wratten Filter Number	Filter Color	Filter Factor for Daylight*	Filter Factor for Tungsten*	Possible Uses
6	yellow	1.5	1.5	Darkens sky slightly
8	yellow	2	1.5	Accurate correction of panchromatic film to daylight; darkens sky
11	yellow-green	4	3	Darkens sky and lightens foliage; accurate correction of panchromatic film to tungsten light
12	yellow	2	1.5	Greater darkening of sky and cutting of atmospheric haze
13	yellow-green	5	4	Darkens sky and lightens foliage; gives swarthy flesh tones to male portraits with tungsten light
15	deep yellow	3	2	Dark skies; darkens water in marine scenes
16	orange	3	3	Dramatically dark skies; greater haze cutting than yellow filters
21	orange	5	4	Dramatically dark skies; greater haze cutting than yellow filters
23A	light red	6	3	Dramatically dark skies; darkens water in marine scenes
25	red	8	6	Extremely dark skies; normal filter for most infrared films
29	dark red	16.4	4	Most dramatic film to darken sky with panchromatic film; used with infrared film
33	magenta	3	3	Darken foliage; lighten sky
44A	cyan	6	12	Lighten water in marine scenes; lighten sky; darken sunset; lighten foliage
47	dark blue	6	8	Accentuate fog and haze for mood; lighten water, darken foliage
58	dark green	8	8	Dark sky, very light foliage
61	dark green	10	10	Dark sky, extremely light foliage
23A+58	red+green	run tests		Used in combination with slight underexposure to create day-for-night effects
87	black	run tests		Infrared transmitting only; used with infrared film

* Approximate values only. See the chart on page 37 for specific value of film in use.

situations. For example, color casts can be particularly effective with strong graphic elements in silhouette.

○ SEPARATING TONES

Once the relationship between the color of the filter and the colors it lightens and darkens is understood, choosing the correct filter to provide tonal separation in black & white photography becomes less of a mystery. In the case of the red and green apple discussed previously, a red filter would lighten the gray value of the red apple and darken the gray value of the green apple since red is complementary to cyan, of which green is a component. Similarly, a green filter would lighten the green apple while darkening the red, since green is complementary to magenta, of which red is a component. Now the question becomes which filter to use.

The answer lies at the very heart of photography: what is the photographer's reason for making the photograph? If it is to produce an accurate translation of the scene from color to black & white, the correct choice would be a green filter, since the eye perceives the green apple as lighter than the red.

Filter choice is usually determined by deciding how the center of interest needs to be lightened or darkened in order to separate it from its surroundings. While this is often thought of as "contrast control," it is inseparable from the "corrective" effect, discussed above, that the filter would have on the scene. Both must be taken into account when selecting a filter for black & white photography.

For example, in still-life photography, to use the red and green apples again, the green filter provides tonal correction and, if the apples are sitting in a blue or yellow bowl, also provides contrast between them and their surroundings. If they're sitting in a red or green bowl, contrast control is going to be a problem. The solution would be beyond what could be corrected simply with filters. The ideal solution is to change the bowl to another one that's either blue or yellow, or maybe one of moderately-stained blond wood.

In portrait photography, the subject must be rendered with correct tonal relationships and must contrast to the surroundings, which includes not only the background, but also hair and clothing. Filters have little effect on dark-skinned individuals, but a yellow filter (#8) used with lighter-skinned, non-blond-haired subjects or a yellow-green filter (#11) with lighter-skinned, blond-haired subjects, along with appropriate background and clothing can be effective.

To achieve the rugged, masculine look with male subjects popularized by the great Hollywood portrait photographers of the 1930s and 1940s, use a #13 or #58 green filter with tungsten lighting. Red filters are seldom used in portraiture except for special effects, since they eliminate separation between skin and lips and emphasize blemishes.

In landscape photography, the sky often makes up a predominant element in the composition. Without filtration, it will be translated into a much lighter gray value than it appears to the eye. A cloudless sky

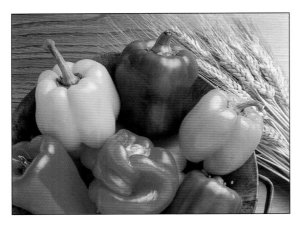

Original color image

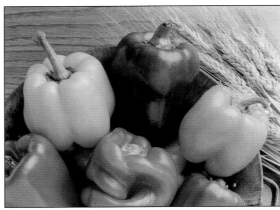

No filter

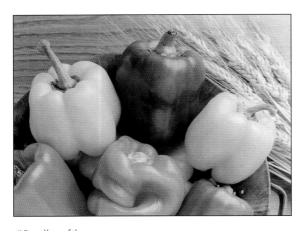

#8 yellow filter

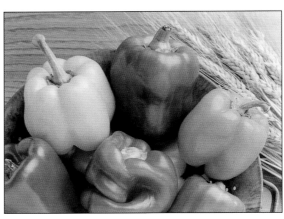

#11 yellow-green filter

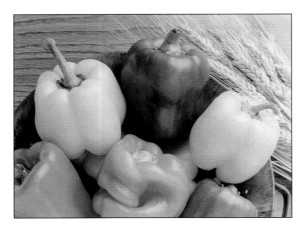

#15 deep yellow filter

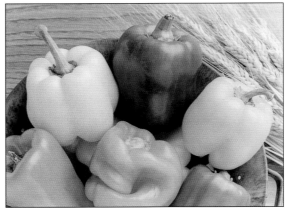

#21 orange-red filter

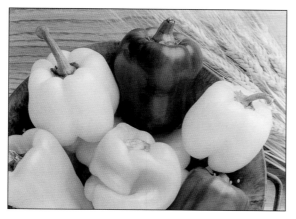

#25 red filter

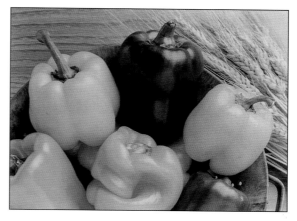

#33 magenta filter

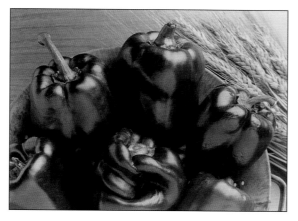

#47 dark blue filter

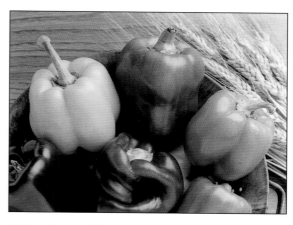

#58 dark green filter

Using filters with black & white film allows the photographer to shift the tonal relationship between objects, thereby altering the contrast and tonal separation of the objects. In the color version, the different hues of the peppers serve to provide separation. However, this is nearly lost in the unfiltered print where the yellow and orange peppers are nearly the same gray value and the upright green pepper is too dark. Different filters alter the tonal relationships between the peppers, with the most tonal separation provided by the #11 yellow-green filter.

can be "corrected" with a yellow filter. But a green or, even more dramatically, a red filter will provide contrast control if there are clouds present, darkening the blue sky while having no effect on the white clouds.

If green trees are an element in the landscape the green filter will lighten them, providing contrast with the sky, which the green filter darkens. However, in autumn, when the leaves are turning, the red filter would lighten them against a dramatically darker sky. It is important to move beyond the rigid think-

CONTROLLING SUBJECT TONAL VALUE

Subject Hue	Variations of the Subject Hue	Wratten Filters That Will Darken Gray-Tone Value in the Print	Wratten Filters That Will Lighten Gray-Tone Value in the Print
Yellow	lemon, tan, gold; light oak and pine wood finishes	blue (47)	yellow (6, 8, 12, 15) yellow-green (11,13) red (25), green (58)
Yellow-Green	chartreuse, olive	blue (47), magenta (33)	yellow (6, 8, 12, 15) yellow-green (11, 13) green (58)
Green	lime, emerald, kelly, forest	blue (47), magenta (33), red (25)	yellow (6, 8, 12, 15) yellow-green (11, 13) green (58), cyan (44A)
Cyan	blue-green, aqua, turquoise, sea-green	red (25)	green (58), cyan (44A) blue (47)
Blue	sky blue, powder blue, royal blue	red (25), green (58), yellow (6, 8, 12, 15) yellow-green (11, 13)	blue (47), cyan (44A), magenta (33)
Violet	lilac, orchid, purple, lavender	green (58), yellow-green (11, 13) yellow (6,8, 12, 15)	blue (47), magenta (33)
Magenta	fuchsia, maroon	green (58), yellow-green (11, 13)	blue (47), magenta (33), red (25)
Red	pink, rose, crimson, scarlet, brown; mahogany, walnut and cherry wood finishes	green (58), cyan (44A), blue (47)	red (25), magenta (33), yellow (6, 8, 12, 15)
Orange	Caucasian skin, brown, beige, auburn	green (58), cyan (44A), blue (47)	red (25), magenta (33), yellow (6, 8, 12, 15)

ing of "yellow filter brings out clouds" to consider the entire scene, and how filters will change the tonal relationships of all of the important elements in it. The above table lists filters that will darken or lighten the gray-tone reproduction for common hues and their variations.

It's worth mentioning that filters will have no effect on a totally overcast gray sky, on white clouds or, for that matter, on any neutral value, because all colors are present in equal amounts in neutrals. While a red filter will absorb the green and blue components of the neutral, increasing the exposure by

the filter's "filter factor" raises the exposure of the red light transmitted to the amount of the original neutral. Thus a properly exposed picture of an 18% gray card shot without the red filter and then again with the red filter, compensating for the filter factor, would yield the same density negative.

Photographing an 18% gray card is, in fact, the best way to determine the actual filter factor for any camera/lens/filter/developer combination. Photograph a gray card without the filter, and then make a series of bracketed exposures with the filter over the lens on the same roll, recording the exposures. Develop normally and match the negative of the gray card without the filter to one with the filter. Check the notes for the exposure increase and use this value in the future. Shooting and processing a test roll is important, particularly when doing critical work, as newer black & white emulsions

Black & white infrared films are sensitive only to radiation beyond the red end of the visible spectrum when exposed through a red or visually-opaque infrared-passing filter. For this reason, it produces a very different result than panchromatic film, as in this photo of a bonsai tree made in the studio under tungsten lighting on Kodak High Speed Infrared film with a #25 red filter.

have decreased red sensitivity and may not have exactly the same filter factor as that given in the black & white filter table found on page 38.

● BLACK & WHITE INFRARED PHOTOGRAPHY

While photography requires light, that light doesn't have to be visible. Outside of the visible spectrum, on the opposite end from ultraviolet light, lies infrared. Several film manufacturers supply black & white emulsions that have been sensitized in varying degrees to reflected infrared energy. All of these films require a strong red filter to block most or all of the visible and ultraviolet light and to transmit red and infrared.

Infrared films and a #25 filter are the most common combination. A #29 filter absorbs more of the visible light and creates an even more dramatic effect, but not as much as the #87 and #87C filters, which are totally opaque to visible light, transmitting only infrared and longer wavelengths. In-camera meters will give an incorrect reading with these filters since the metering cell's infrared sensitivity differs from the film's. Experience is the best guide. Use the information sheet packaged with the film as a starting point.

Since green foliage reflects infrared strongly, plants and trees are reproduced in very light values in the print. Infrared films provide dramatically dark skies with bright white clouds since the filter is absorbing the blue of the sky and the scattered blue light of the atmospheric haze.

Less dramatic haze cutters and other filters that can be used with both black & white and color films are the subjects of the next chapter.

FACING PAGE: Infrared film used out of doors with a red filter produces deep black skies and brilliant white clouds while lightening green leaves, which reflect infrared light strongly.

CHAPTER 3

FILTERS FOR BLACK & WHITE AND COLOR PHOTOGRAPHY

There is a great deal of crossover in the use of filters. Photographers have successfully used many of the filters discussed in the previous chapter for special effects with color film. For example, with a simple shape in silhouette in the foreground, a red #25 filter will produce a monochromatic, red image with the feeling of intense heat. Likewise, filters discussed in chapter 4 could be used with black & white films, but the effects would be practically invisible because the filters don't have sufficient color absorption to significantly affect the film.

There are filters, however, that are often used interchangeably with color or black & white films. These include UV/haze filters, polarizing filters, neutral density filters and close-up filters. None has a significant effect on the way color is recorded on the film. In fact, nearly all of them are clear, or absorb all wavelengths of visible light equally.

● ULTRAVIOLET AND HAZE FILTERS

The atmospheric haze visible in distant scenes is a mixture of water vapor, hydrocarbons and airborne dust particles that scatter the shorter wavelengths of sunlight. When this scattered light reaches the camera it is recorded as a bluish cast on color film, or a lowering of contrast on black & white film. Haze filters are designed to penetrate this haze, reducing the bluish cast of distant scenes on color film and raising the contrast of the image on black & white emulsions. Unfortunately, they have little effect on the yellowish-brown smog increasingly present from man-made pollutants.

As mentioned in the previous chapter, there are many filters in the yellow and red families that are effective in minimizing or totally eliminating haze when using panchromatic black & white films. With color transparency film, there are fewer options.

Most effective at penetrating atmospheric haze is the skylight 1A filter, which adds a

FACING PAGE: By using filters designed for black & white photography with color film, it is possible to create a strong mood. The same scene can give the feeling of intense heat by using a #23A filter or appear to be taken by moonlight by using a #47 filter.

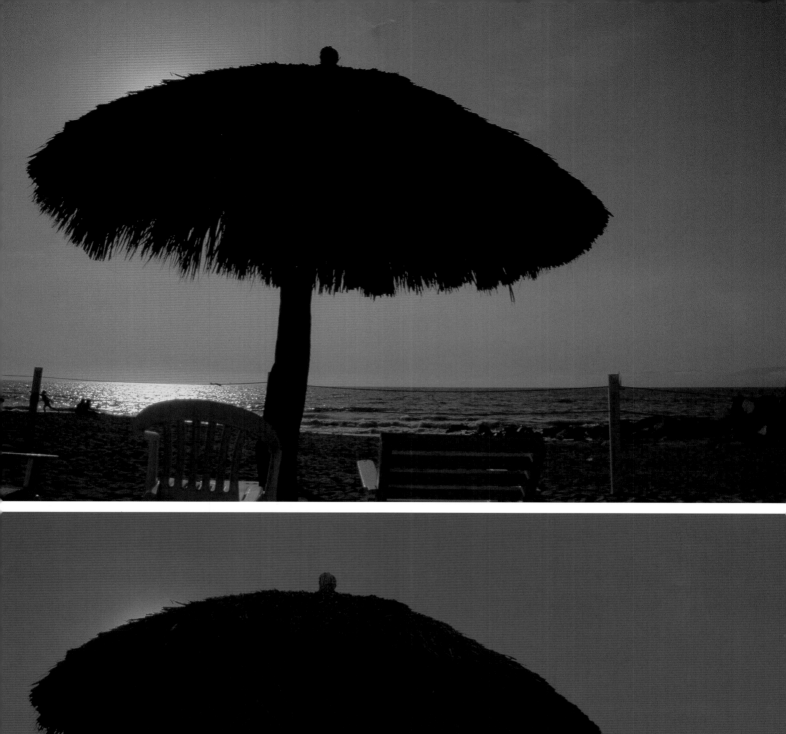

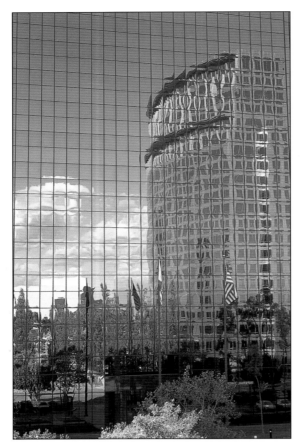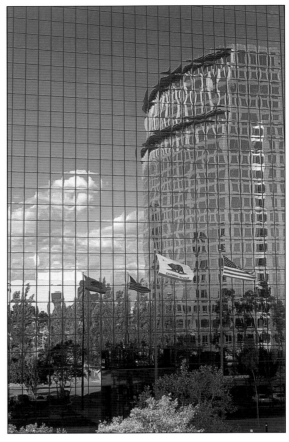

Polarizing filters are often used to eliminate reflections in glass windows, but, by choosing a different shooting angle, they can also be used to polarize the scene reflected in the windows, as in this example.

slightly pinkish cast. It is the only filter discussed in this chapter that will alter the color balance of a scene, imparting a slight warming effect while minimizing the haze in distant scenes. Many photographers keep a 1A filter on each of their lenses at all times. This not only adds a little warmth to the scene, it also provides protection for the lens. If a 1A filter is used for all shooting, it's recommended that a multicoated filter be used. Multicoating minimizes flare resulting from the additional glass surfaces.

Even scenes where the air appears clear can benefit from use of an ultraviolet-absorbing filter. Mountain or marine environments, for example, contain large amounts of UV radiation, which is invisible to the eye, but affects the film by increasing exposure of the blue layer. For color transparency film, the UV (0) filter is available. Like the skylight filter, it can be left on the lens at all times, but unlike the skylight filter, it gives no warming effect.

FACING PAGE: Polarizers can be combined with other filters, such as a CC10R used in this photo to enhance the color of the rocks. If non-glass filters are used, they should be put between the lens and the polarizing filter, not in front of the polarizer.

Stronger UV filters like the #2A, #2B and #2E, which absorb some blue light, are available for color negative films. Their yellowish tints are corrected in printing, but they are unsuitable for transparency emulsions.

Besides the skylight and UV filter, the polarizing filter is the only other possibility for transparency shooters to penetrate aerial haze. But this is only one of its many uses.

● POLARIZING FILTERS

As mentioned above, haze is the result of blue light being scattered by the atmosphere. The sky appears blue for the same reason—blue light is scattered more intensely than longer wavelengths. When light is scattered or reflected, it becomes polarized. To better comprehend what this means, it is necessary to understand more about the nature of light.

With the sun low in the sky at early morning, a polarizing filter will have its strongest effect on the sky directly overhead, as shown in this shot. (photo by Ron Eggers)

Although light is more accurately described as packets of energy called photons, it's possible to simplify the theory and think of light as waves rather than particles for the purpose of understanding polarization. To relate light to everyday experience, picture a long rope tied to a ring at one end. If the free end is picked up and shaken up and down in a line, a series of waves move down the rope to the far end.

In a similar way, light moves in one direction—as a series of waves—and the distance between consecutive wave tops is the wavelength of the light. But there is a major difference between light and the rope—light vibrates randomly in all directions perpendicular to the direction of its travel.

When this randomly vibrating light is scattered, some of it ends up vibrating more strongly in one plane than in all others, much like the rope example. This scattered light is said to be polarized.

A polarizing filter is made up of a grid-like foil cemented between two pieces of glass. The foil is designed so that only light waves vibrating parallel to the grid of the foil are transmitted. Those rays vibrating perpendicular to the grid are completely blocked and vibrations in other directions are partially blocked.

When using polarizing filters for landscape photography, it is possible to control the saturation of the sky from virtually unchanged

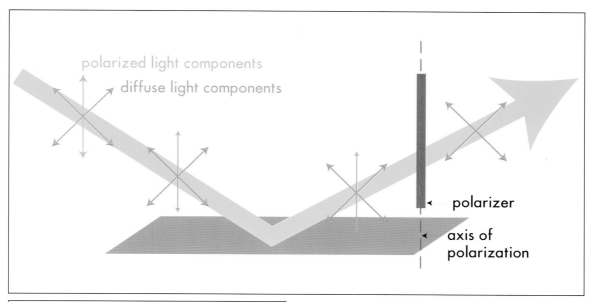

polarized light components

diffuse light components

polarizer

axis of polarization

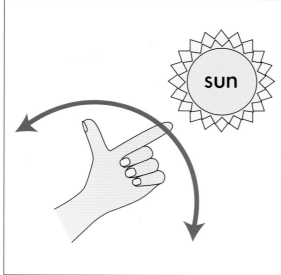

sun

To determine what part of the sky will be darkened with a polarizing filter, point at the sun with your index finger. Raise your thumb perpendicular to your index finger and rotate it. The arc made by your thumb is the area of the sky where the polarizer will have the greatest effect.

ABOVE: When unpolarized light strikes most surfaces, the reflected light consists of a highly polarized component and diffuse components. When the axis of polarization of the polarizing filter is perpendicular to the polarized light, this component is eliminated. This allows the diffuse components of the light to pass and be recorded.

to deep blue depending on the placement of the sun in the sky. The maximum effect will occur in that part of the sky that is 90° from the sun. To visualize where this area is without looking through the polarizer, point your index finger in the direction of the sun. Raise the thumb of the same hand until it is perpendicular to the index finger and rotate the hand. The arc that the thumb makes in the sky will be the area where maximum darkening will occur.

Increasing the saturation of the blue sky increases the contrast of sky and clouds. Under other conditions and light angles, it is possible to eliminate some of the clouds from the sky! Remember that clouds are white because they scatter all wavelengths equally, but the light we see is still scattered light and therefore polarized. Under the right conditions, it's possible for the polarizer to eliminate them partially or completely.

Scattering is not the only way light can be polarized. Passing light through a polarizing

An oil painting can exhibit tiny specular highlights from the brush strokes, as well as overall glare from the copy lights illuminating it, as seen in the left photo. In order to eliminate both and show the true colors of the work (right photo), polarizing filters must be placed over the lights and over the lens.

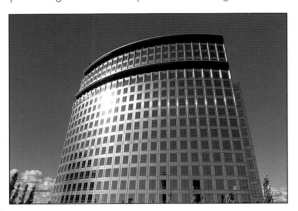

Polarizing filters have no effect on reflections from unfinished metal surfaces. No matter what the sun angle, reflections from this stainless steel—clad building (left) are unchanged, although the polarizer darkens the sky behind the building (right).

filter is another way. Once light has passed through the first polarizing filter, a second polarizer can be used to partially or completely block the light, depending on the orientation of the two filters. This technique is often used when copying artwork to eliminate highlights from the work and from the surrounding frame.

One copy light is positioned to shine through a sheet of polarizing material that is oriented with its polarizing angle horizontal. The polarizing filter over the lens is adjusted

until the reflection of this light is eliminated. The second copy light is then turned on and its polarizing sheet is rotated until there is no reflection from this source. With such a setup, the diffuse reflection underlying the copy light reflection can be seen.

Light can also become polarized when it is reflected from a surface, but not all surfaces. When light strikes a rough-textured surface, its random nature is not affected, and the surface is called diffuse. Unfinished metal surfaces also have no effect on the random

nature of light waves. Therefore, a polarizing filter will do nothing to eliminate the reflection of the sun off of a stainless steel building.

In between these two extremes are numerous surfaces, including glass, water, wood, grass, leaves and many others whose reflected light is at least partially polarized. The degree of polarization depends on the angle of incidence of the light and varies from material to material. Light reflected off water has a maximum polarization of just under 37°, while maximum polarization of light reflected off glass is about 32°, depending on the type of glass. Under ideal conditions, reflections can be completely eliminated when the angle of the light to the surface and the angle of the camera lens to the surface are almost equal and in the range of 30° to 40°.

Polarizing filters increase contrast and saturation by eliminating light that has been polarized by the surface and strongly reflected. This makes it possible to photograph the weaker diffuse reflection off the surface. The cost is a loss of about half of the visible light, requiring an exposure increase between $1\frac{1}{3}$ and two stops (filter factor of 2.5 to 4). This exposure increase is constant no matter what angle the polarizing filter is turned to or the degree of reflection reduction.

However, the filter factor does vary depending on the filter manufacturer and the shooting conditions. In-camera meters will compensate for this light loss, provided the proper polarizing filter is attached to the lens when metering.

There are two types of polarizing filters made for photography: linear polarizers and circular polarizers. Before TTL (through-the-lens) metering, autofocus and autoexposure cameras, all photographic polarizers were the linear type, consisting of a foil of polarizing material between two sheets of glass. These new technologies rely on a beamsplitter to send part of the light entering through the lens to the meter and autofocus mechanism and part to the viewfinder. Because of the beamsplitter, light entering the meter is partially polarized. A linear polarizer placed over the lens in this type of system acts as a second polarizer, blocking light to the meter in amounts depending on the angle between the beamsplitter and the polarizing filter. Circular polarizers eliminate these problems.

By adding another foil of precisely the right thickness behind the linear polarizing foil in the filter, circular polarizers change the linear polarization into an orientation that appears to be unpolarized to the meter. Going back to the rope illustration above, if the free end of the rope is moved in a circle, circular waves will travel down the rope. This is what circularly polarized light is like.

While this eliminates exposure problems, it adds to the cost of the filter and adds another piece of material between the scene and the film, potentially resulting in image degradation. If the light reading is done with a handheld meter, the filter factor applied, and the camera exposure and focus set manually, there is no reason why linear polarizers cannot be used, even when the camera manufacturer recommends otherwise. On the

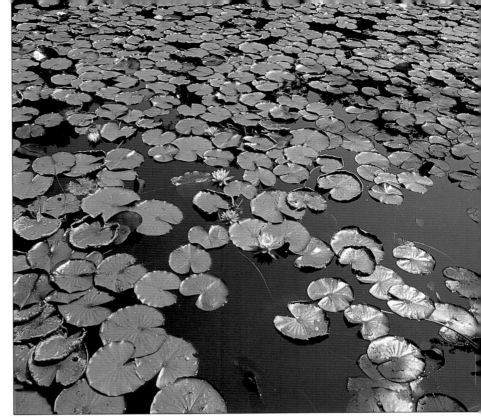

Light reflecting off the water and lily pads in the photo on the right is polarized, and desaturates the colors of the scene. A polarizing filter eliminates the glare and restores the color saturation.

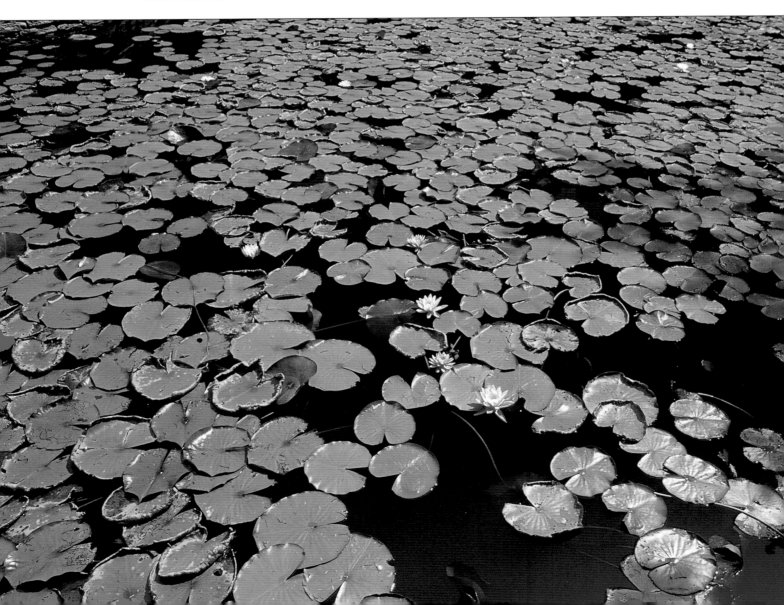

other hand, circular polarizers work not only with newer cameras—they also work fine with earlier models.

Both types of polarizing filters are available from many different manufacturers. By their nature, polarizing filters do not benefit from a single layer of antireflection coating, but multicoating, particularly of the exposed rear surface, is beneficial. Polarizers are also available with a skylight filter incorporated into them for a warming effect and increased haze penetration. This type of filter is especially useful with wide-angle lenses, where vignetting may occur when individual filters are stacked together.

Also available for wide-angle lens users are polarizers in ultrathin mounts that prevent vignetting. At least one manufacturer realizes that not all photographers use single lens reflex cameras, and supplies polarizers with both the axis of polarization and convenient index marks clearly indicated on the filter rim. With these calibrations, it is possible to hold the filter up to the eye, rotate it until the desired effect is seen and note the index marks on the rim. The filter is then mounted on the lens and rotated until the index marks are in the same position noted when the filter was held in front of the eye.

Some manufacturers sell a specialized polarizing filter called a Kaesemann polarizer. Available in both linear and circular types, this extremely high quality filter has the internal foil(s) stretched and held under tension in all directions so that the material is perfectly flat. Additionally, the glass is of the highest quality and all surfaces are exactly parallel. The edges are totally sealed so that it is unaffected by moisture and fungus. The advantage is a slightly greater polarizing effect and minimal image degradation with fast telephoto and apochromatic lenses (lenses corrected so that red, green and blue wavelengths come to a common focus).

● NEUTRAL DENSITY FILTERS

With lens apertures from f2.8 to f22 and shutter speeds from thirty seconds to $\frac{1}{8000}$, it's hard to imagine that a photographer would have a problem finding a combination of aperture and shutter speed to match any shooting requirement he or she might encounter. There are times, however, when a photographer might want to make an exposure with a shutter speed and aperture combination that the existing light conditions won't permit. That's when neutral density filters, which are designed to reduce exposure without affecting color balance or contrast, may be the solution.

The image quality of high-speed films is so high, particularly in color and black & white negative emulsions, that a photographer might be tempted to load the camera with one of them and shoot with it indoors and out. There comes a time, however, when an outdoor photo calls for an aperture of f2.8 to blur the background, or a shutter speed of one second for panning or zooming, with these films. These are only a few of the instances in which neutral density filters come in handy.

Neutral density (ND) filters are available in three varieties: evenly coated; graduated, with a part of the filter clear and part coated;

KODAK WRATTEN NEUTRAL DENSITY FILTER #96

Neutral Density	Filter Factor	Increase in Exposure (Stops)
0.1	1.2	$\frac{1}{3}$
0.2	1.5	$\frac{2}{3}$
0.3	2	1
0.4	2.5	$1\frac{1}{3}$
0.5	3	$1\frac{2}{3}$
0.6	4	2
0.7	5	$2\frac{1}{3}$
0.8	6	$2\frac{2}{3}$
0.9	8	3
1.0	10	$3\frac{1}{3}$
2.0	100	$6\frac{2}{3}$
3.0	1,000	10
4.0	10,000	$13\frac{1}{3}$

and center weighted, with the center coated and the outer edge clear.

Evenly coated ND filters are available in densities up to a filter factor of 1,000,000 for specialized scientific applications! Photographers seldom have need for anything greater than a filter factor of eight requiring an exposure increase of three stops. If the need arises, these filters can be used in combination with one another to decrease exposure further. The above table shows the common neutral density filters, along with their filter factors and the exposure increase necessary for each.

Several manufacturers offer a continuously variable neutral density filter, often called a double polarizer. It consists of two sheets of polarizing material in the same filter mount. When the axis of polarization of the two coincide, the filter cuts the light by about 1½ stops, as if there were only one polarizing sheet present. As the filter is rotated, the light is slowly cut off until practically no light passes when the two sheets are at an angle of 90° to one another.

Graduated neutral density filters are essential accessories for the landscape photographer. They are most commonly used to control areas of excessive brightness, such as the sky, to bring its exposure more in balance with the rest of the scene.

Many types are available, although all have a clear area over one half and some degree of neutral density over the other. The transition between the two areas can be abrupt, which is commonly used when there is a distinct horizon separating foreground and sky, or gradual, for a softer effect.

Round, screw-in ND graduated filters ("grads") rotate much like polarizing filters so that the transition can be adjusted to match the horizon. The disadvantage of this type is that the transition area is fixed, beginning in the center of the frame and moving outward, requiring the photographer to place the horizon near the center of the photo. However, when round ND grads are used in combination with one another or with round, colored grads, which will be discussed in chapter 5, aligning the transition areas is easier than with rectangular grads.

The dark area of rectangular neutral density graduated filters generally covers less than half of the filter area. These filters are designed to slide in the manufacturer's filter

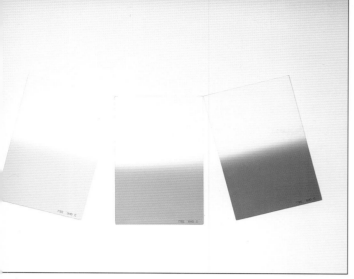

LEFT: Graduated neutral-density filters are available in a variety of sizes and strengths. Some have a soft transition from clear to neutral density while others have a harder transition. These Lee filters are available in a set, with densities of one, two and three stops.

BELOW: Shutter speeds of thirty seconds and longer flatten out the ocean's surface and give it a misty look. Seven stops of neutral density were needed in this sunset photo for a thirty-second exposure at f16 on Kodak 100VS.

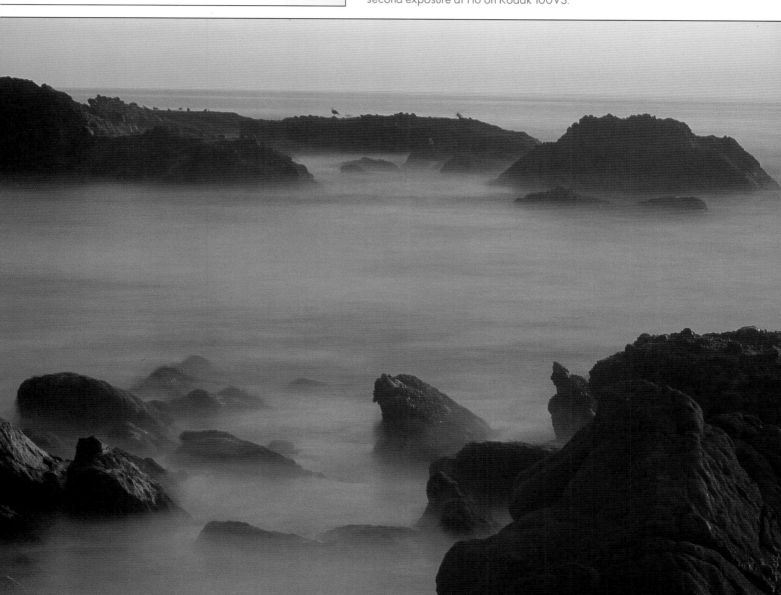

holder so that the transition area can be positioned anywhere in the frame. While the clear and dark areas are quite obvious when the filter is off the lens, it is far less so once the filter is mounted.

When this type of filter is used to darken the sky, it is best to meter the foreground with the in-camera or handheld meter and set the exposure manually. After the filter is attached, the depth of field preview button can be used to stop the lens down to the aperture selected. Once this is done, moving the filter up and down will make the transition area readily apparent and allow it to be positioned exactly where it will give the desired result.

Determining what density filter is required is best done with a spot meter. One reading is taken of the foreground and a second of the sky, about halfway from the horizon to the highest point that will appear in the photo. If the difference between these readings is one stop, then a one-stop grad is a good starting point. More or less darkening can be accomplished with stronger or weaker filters. For the most believable result, the sky should still appear to be brighter than the foreground in the final image.

One or 1½-stop ND grads are all that are usually required to bring the sky into the exposure range of the foreground, but there are exceptions. One situation would be when photographing in the cooled lava fields of Hawaii. In that situation, it's desirable to hold definition in both the black lava and in the clouds. Here, a neutral density grad of three stops or more is required.

Ultra wide-angle lenses designed for large-format cameras often display light falloff from the center of the frame to the edges. This can be seen in the 6x17cm panoramic photograph above, taken with a 90mm f5.6 Super Angulon. Center-weighted neutral density filters are available from the lens manufacturers to even out the exposure. (photo by John Lawder)

Neutral-density graduated filters aren't only for darkening skies. They can be used equally effectively to darken reflections from the surface of a backlit lake by placing the graduated area over the foreground.

The smoothness of the transition from clear to dark in the final photo depends on a number of factors. These include the design of the transition on the filter itself, the focal length of the lens, the distance of the filter from the lens and the shooting aperture. Wide-angle lenses at small apertures will give a sharp transition even with softly graduated filters. Telephoto lenses used wide open may require a hard gradation on the filter for the darkening to be noticeable at all.

Studio photographers as well as landscape photographers make use of the ND grads. Products are often photographed with soft, nearly shadowless lighting from broad overhead sources, giving an evenly lit background. One easy way to provide a gradation from subject to a darker value background is to use a graduated neutral density filter. By choosing the desired density and positioning it carefully with the lens stopped down, background exposure can be completely controlled.

Center-weighted neutral density graduated filters are designed for use with specific wide-angle lenses to eliminate the inherent light falloff they produce at the edges of the frame. Lenses where this is most apparent are used with large-format and panoramic cameras. The falloff is generally about one stop and the filter corrects this so that the exposure is even from corner to corner. In reality, while these filters work, many large-format and panoramic photographers elect not to use them, preferring the slight darkening at the edges to draw attention to the center of the image. Extreme wide-angle lenses for 35mm cameras show this light loss, but to a much smaller degree because of the difference in lens design; therefore, these filters are seldom used.

● CLOSE-UP FILTERS

When the minimum focusing distance of a camera lens isn't sufficient to fill the frame with the subject, close-up filters are used to extend the close focusing distance. They are widely available in sizes to attach to the front of nearly any lens and come in a range of strengths, from 0 to 10, with magnification increasing as the numbers get larger. Close-up filters increase the focal length of the lens without requiring any increase in exposure. The strength of these lenses is measured in diopters. A "diopter" is the reciprocal of the close-up lens' focal length in meters (1/focal length). Thus a +1 diopter lens has a focal length of 1 meter or 1000mm, a +2 diopter lens a focal length of $(\frac{1}{2})(1 \ meter)=0.5$ meter or 500mm, etc.

A diopter acts like a magnifying glass when placed in front of a camera lens focused at its infinity setting. The lens-to-subject distance of closest focus is equal to the focal length of the diopter. A +1 diopter lens fitted to any lens focused at infinity will be able to focus on an object 1000mm or about 39.5 inches away. Any object further than that cannot be brought into focus, but objects nearer can be brought into focus up to a minimum distance determined by the lens.

The focal length of the camera lens determines the field size (magnification) when the supplementary lens is attached. For example, a 100mm lens fitted with a +1 diopter close-up lens and a 50mm lens fitted with a +1 diopter close-up lens will both be able to focus on an object 39.5 inches away. However, the object will be twice as large with the 100mm lens.

In theory, close-up filters placed very close to the elements of the camera lens will yield

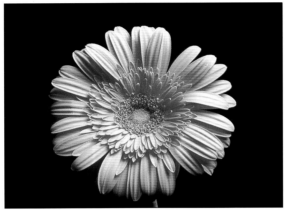 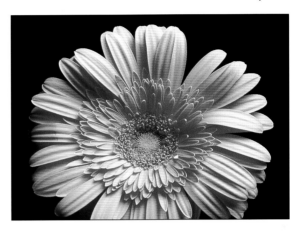

Close-up filters extend the close-focusing distance of any lens. Here they were mounted on a Nikkor 105mm f2.5 lens. The first photo shows the maximum image size when the lens is focused at its minimum focusing distance. The others were taken with a close-up lens attached: Nikon "0" (0.7 diopter), Nikon "1" (1.5 diopter), Nikon "2" (3.0 diopter) and Nikon "0" and "2" combined. High quality close-up filters must be used to give satisfactory results when more than one filter is used.

SUPPLEMENTARY CLOSE-UP LENSES

Close-up Lens Diopter Strength	Lens-to-Subject Distance (inches)*	Approximate Field Size (inches)**	Magnification	Approximate Depth of Field at f/8 (inches)
+1	39.5	18x27	0.05x	9
+2	19.5	9x13.5	0.1x	2.5
+3	13	6x9	0.15x	1
+4	10.875	4.5x6.75	0.2x	0.5
+5	7.875	3.625x5.375	0.25x	0.375
+6	6.5	3x4.5	0.3x	0.25

*Lens-to-subject distance applies to any focal length lens.
**Field size and reproduction ratio apply to 50mm lens focused at infinity.

image quality equal to the quality possible from the camera lens alone. This being the case, the higher the quality of the camera lens, the better the results after attaching the close-up lens. In practice, even the highest quality diopters introduce some aberrations that can affect the quality of the images. Those aberrations increase with the focal length, the aperture of the lens and the strength of the diopter. Stopping the camera lens down to an aperture of f/11 or f/16 reduces some of those aberrations, but that doesn't necessarily eliminate them. Close-up lenses themselves vary widely, so considerable care should be taken to buy both quality lenses and quality close-up filters. Some manufacturers sell multielement close-up lenses. They carry higher price tags, but the additional element allows for better correction of factors that can degrade the image.

There are a number of things that should be kept in mind when selecting close-up filters. One is that the numeric designation that manufacturers put on them is not necessarily the diopter value. With Nikon, a No. 0 close-up adapter is a +0.7 diopter, a No. 1 is +1.5 and a No. 2 is +3.0.

It is possible to use close-up lenses in combination, but there is a further degradation of image quality. Again, stopping down the lens can minimize that degradation. When used in combination, the higher-power lens should be closest to the camera lens. A +1 diopter in combination with a +2 diopter will yield the equivalent close-focusing capability of a +3 diopter, but the image quality is better if a +3 diopter were used alone. Two high-quality supplementary filters of low to medium power used in combination will yield very good results. If necessary, three adapters can be used together, but it's not recommended. The potential loss of quality is too great.

Depth of field with supplementary filters is minimal. When attached to a 50mm lens set at f/8 and focused on infinity, it varies from approximately 9 inches with a +1 diopter to 1.0 inch with a +3 diopter. At closer focusing ranges and with longer focal-length lenses, the depth of field is even less. The chart found above shows the minimum focusing distance for common supplementary close-up lenses and combinations of them for prime lenses to which they are

attached. Also shown are the approximate field size, magnification and approximate depth of field at f/8 with a 50mm lens focused at infinity.

● SPLIT-FIELD FILTERS

A subtype of close-up filter is the split-field attachment. Most of these consist of a close-up filter in ½ of the retaining ring and clear glass, or nothing, in the other half. B+W Filters makes bifocal filters of several strengths where the curved close-up lens portion covers only about ⅓ of the filter area, much like a bifocal eyeglass lens. The split-field filter allows very close and distant objects to be brought into focus at the same time, creating apparent increases in depth of field.

A foreground flower and a distant mountain can both be imaged sharply using a split-field filter. Without the filter, the lens would be incapable of doing this, even at its smallest aperture. After attaching the split-field filter, compose the shot and focus the lens on the distant subject. Then move back and forth until the foreground subject is in focus. The trick in using such a filter is to place the transition area between the close-up area and the rest of the scene in a part of the image where there is no important detail. The transition is also less noticeable with longer focal length lenses used at large apertures.

CHAPTER 4

FILTERS FOR COLOR PHOTOGRAPHY

Color film is balanced for one of two different color temperatures of light. Daylight film is balanced for 5500° Kelvin and Type B film is balanced for 3200° Kelvin. However, daylight and Type B color negative film can often be corrected in printing when lighting conditions vary from the ideal for which they are designed. Color transparency films, however, will show color shifts in neutral gray areas, even when the Kelvin temperature varies by less than 100° from the color temperature for which the film is balanced.

To correct color transparency film so that neutral values will record as neutral, three types of correction filters are available: color-conversion, light-balancing and color-compensating. While these filters are grouped into these three categories their use isn't limited to those applications—they can be used creatively to subtly enhance specific colors or to alter the mood of the photographs.

● COLOR–CONVERSION FILTERS

When daylight-balanced film is exposed indoors under tungsten lighting, the result-ing slides will have a strong orange cast because of the mismatch between the color temperature of the light source and the color temperature for which the film is balanced. In the same way, exposing Type B film outdoors will result in a major mismatch of color temperatures, resulting in slides with an overall blue cast. Correcting these mismatches is accomplished with the 80 (blue) and 85 (amber) series of conversion filters.

The four filters of the 80 series balance the color temperature of four specific incandescent light sources for use with daylight-balanced film. Because of the large amount of red that must be removed, these strongly blue-colored filters require a significant increase in exposure. The most commonly used, the #80A, which converts 3200° Kelvin sources commonly used in theater stages and photo studios to daylight balance, requires a two-stop exposure increase.

Daylight contains a large amount of yellow and red light. So the three filters of the 85 series only need to remove some of the blue

No filter

#81EF filter and Cokin 120 Gray 1 grad in sky

#85C filter and Cokin 120 Gray 1 grad in sky

CC10R filter and Cokin 120 Gray 1 grad in sky

CC30R filter and Cokin 120 Gray 1 grad in sky

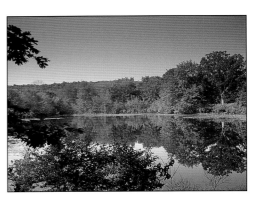

CC30R filter and Cokin 124 Tobacco grad in sky

Color-conversion, light-balancing and color-compensating filters can all be used to change the mood of a photograph by altering its overall color temperature or subtly enhancing certain colors. Used in combination with other filters, the effects are limitless.

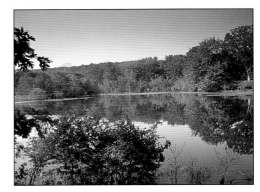

CC30R filter and Cokin 123 Blue 2 grad in sky

80 AND 85 SERIES COLOR-CONVERSION FILTERS

Filter Effect	Filter Number	Increase in Exposure (Stops)	Kelvin Conversion
Cooling	80A	2	3200 to 5500
	80B	1⅔	3400 to 5500
	80C	1	3800 to 5500
	80D	⅓	4200 to 5500
Warming	85C	⅓	5500 to 3800
	85	⅔	5500 to 3400
	85B	⅔	5500 to 3200

present to convert daylight to the proper balance for Type B films, and their filter factors are correspondingly less. For instance, the 85B used to convert daylight for use with Type B film requires an increase of only ⅔ stop. This is why, when professional photographers must use only one type of transparency film for both daylight and indoor shooting, they will choose a Type B emulsion and filter it with an 85B outdoors, where the ⅔ stop light loss is insignificant.

With shifts in color balance as large as those accomplished by color-conversion filters, it should come as no surprise that the results are not perfect for all colors. Some photographers find the slightly warm rendition of some colors with the Type B film/85B filter combination to their liking and make its use standard for all of their outdoor shooting.

Where color fidelity is extremely important, such as in color copy work, it is best to match light source with film type. In most cases this involves 3200° Kelvin quartz-halogen lighting and Type B film. Quartz-halogen lights are preferable over incandes-cent sources since their light output and color temperature is much more consistent over time. Even then, it is advisable to shoot a test with a gray scale or color chart, such as the Macbeth ColorChecker, to ensure that neutrals are being reproduced properly.

To do this test, set the lighting as it will be for the actual photograph. Take a meter reading of the 18% gray card and expose the film. After the film is processed, have the processing lab read the 18% gray card or 18% gray patch of the Macbeth chart with a densitometer. This will show what filter is required to balance the film to neutral for the lighting conditions of the test situation. If a filter is necessary, it doesn't mean there's a problem with the film. It only means that the given lighting conditions require a small amount of correction. To reduce the potential for errant color casts in their shots, most photographers paint their studios white,

In copy work, correct exposure and accurate color reproduction are important. Running a film test using a Macbeth ColorChecker, Kodak Color Control Patches and a Kodak Gray Scale, with the same lighting setup that will be used to make the copies, is the first step in assuring the copy will be correct.

gray or black to reduce the possibility of light bouncing off colored walls.

While color-conversion filters were created for specific technical purposes, their use as creative tools is what puts them in the camera bags of most photographers. The strong effect that color-conversion filters have on light makes them appropriate as mood enhancers in photography.

Heavily overcast and foggy days keep most photographers at home. But these types of days are perfect for loading the camera with daylight film and shooting with a blue 80A filter over the lens to create a moody, monochromatic out-of-this-world effect. As an interesting experiment, go out to the ski slopes with Type B film. The results are totally cool.

Indoor scenes with incandescent light don't need to be corrected back to neutral. In many cases, the warmth of the scene can be an important element of the photo. Using daylight film with an 85 series filter further enhances that warm mood.

Warming filters are also useful for enhancing sunset photos. While other filters specifically designed for this purpose will be discussed in the next chapter, any of the 85 series of color-conversion filters will add significant warmth to the sky as well as the foreground. This effect is strongest in the midtones and shadows and the overall, nearly mono-

A foggy morning, daylight film and an 80A filter combine to give this moody photo of a lone kayaker. Using Type B film with the 80A filter would have resulted in an even cooler rendition.

chromatic effect serves to tie the sky and foreground together in a *feeling* of sunset rather than simply a photo of a sunset.

● LIGHT-BALANCING FILTERS

Like color-conversion filters, light-balancing filters are designed to adjust the color temperature of the available light to that for which the film is balanced. The adjustment they offer, however, is smaller, more in the range of 200–300° Kelvin rather than the 1500–2300° range of conversion filters.

Since the human eye is a relatively poor judge of color casts, use of a color temperature meter is essential where precise light balancing is required, such as in commercial, industrial and architectural photography. Many color temperature meters can be set so that they display the number of the filters that are required.

There are two series of light-balancing filters, the bluish 82 series and the straw-

Light-balancing filters are used alone or in combination to raise or lower the color temperature of the available light in precise amounts. The bluish 82 series of four filters are used to raise the color temperature, while the six straw-colored 81-series filters are used to lower it.

colored 81 series. The table found at the bottom of this page summarizes both series.

Additional shifts in color temperature can be accomplished by combining filters within each light-balancing series or in combination with color-conversion filters. For example, if correction is required for a scene lit by 100-watt household bulbs (approximately 3100° Kelvin) to daylight-balanced film, an 82 light-balancing filter will raise the temperature to approximately 3200° and an 80A will convert the rest of the way to daylight. Exposure would need to be increased by 2⅓ stops.

Technical uses aside, the most common use of light-balancing filters in many applications is for noticeable "warming" and "cooling." Since their effect on color temperature is so much less than color-correction filters, the warming and cooling is far subtler.

Filters in the bluish 82 series are effective in reducing some of the excess red in late after-

81 AND 82 SERIES LIGHT-BALANCING FILTERS

Filter Effect	Filter Number	Increase in Exposure (Stops)	Kelvin Shift
Cooling	82	⅓	-100
	82A	⅓	-200
	82B	⅔	-300
	82C	⅔	-400
Warming	81	⅓	+100
	81A	⅓	+200
	81B	⅓	+300
	81C	⅓	+400
	81D	⅔	+500
	81EF	⅔	+650

No filter

No filter, silver reflector

No filter, gold reflector

Tiffen 812 filter

Skylight 1A filter

81 filter

81A filter

81B filter

81C filter

81D filter

81EF filter

85C filter

The effect of warming filters ranges from the subtle to the obvious, but only when compared to an unfiltered image. Here, various warming filters were used to photograph a model against a neutral gray background to show their effect on skin tone. Also included are examples with no warming filter, and with no warming filter, but with a silver and gold reflectors used on the shadow side of the face.

noon sunlight, minimizing the ruddy red "sunburned" look from front-lit portraits taken during this time of day.

Many photographers find the warming effect of the straw-colored 81 series so appealing that they use one, usually an 81 or 81A, on their lenses at all times, rather than a UV or skylight filter. Both of these filters add a pleasant warmth to portraits taken indoors or out. The look is so appealing that warm-balanced transparency films, such as Kodak 100SW, incorporate the equivalent of an 81A filter into the film.

FILTERS REQUIRED TO CONVERT LIGHT SOURCES TO DAYLIGHT- OR TYPE B-BALANCED FILMS

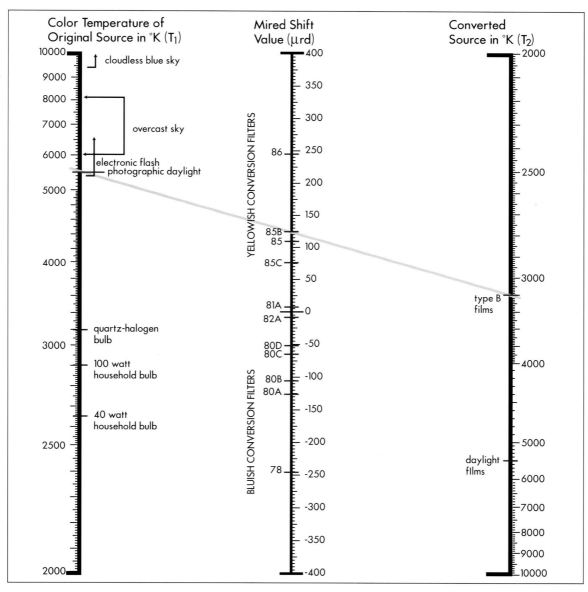

To use this chart, lay a straightedge from the color temperature of the source (left scale) to the type of film used (right scale). The required filter to convert the light source to the film will be seen where the straightedge crosses the center scale. In the example, 5500 Kelvin daylight requires an 85B filter for proper conversion to Type B film.

Landscape and scenic photographers commonly use the 81B. At lower altitudes it is effective in removing the excess blue from shadow areas without giving artificial warmth to sunlit regions. On clear days at higher altitudes, an 81C or even 81D may be necessary to block ultraviolet radiation and decrease the excess blue.

Where the important elements of a composition are entirely in open shade or lit by an overcast sky, the 81EF filter eliminates the cool blue cast and yields a warm, natural-looking skin tone.

The chart found on page 69 can be used as a visual aid in determining which color-conversion and light-balancing filters are required to balance light sources to daylight or Type B film.

Used creatively, light-balancing filters, like color-correction filters, impart an overall "mood" to a photo, but to a lesser extent. Both types can be used to tie the foreground and background together. In doing so, they tend to reduce overall contrast by giving the photo more of a monochromatic look.

Companies throughout the world make light-balancing filters. German manufacturers use the designation "KR" for their warming filters and offer them as equivalent to various Wratten 81 or 85 filters. While the amount of color temperature change may be equivalent, the visual effect is quite different. The color of the KR filters is more of a coral than a straw or amber. Many photographers, especially those using equipment with German lenses, find the results from using KR filters more pleasing and natural than the technically equivalent 81- or 85-series filters.

In the US, Tiffen offers a filter exclusive to it, the 812 Warming Filter, which is also more coral-colored than straw-colored. It appears to offer about as much warming as an 81B, but the effect is somewhat different, resulting in a very natural flesh tone in open shade or with electronic flash. Tiffen offers

Fluorescent lights, if uncorrected, will give a strong greenish cast to subjects photographed with daylight-balanced film. Using the CC40M and CC10Y filters recommended by Kodak for Ektachrome 100S film to correct the Cool White fluorescents in my studio yielded an acceptable result. If the type of fluorescent bulb is unknown, a CC30M filter is a good starting point.

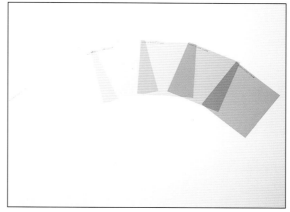

Color-compensating filters are manufactured in the additive and subtractive primaries, red, green, blue, cyan, magenta and yellow in a range of densities for precise control of color. The left photo shows the filters in 0.30 density. The right photo shows the range of densities for the magenta filter from 0.05 to 0.50. Also available is a 0.025 density that is seldom used.

the 812 on its own or in combination with various types of diffusion filters, as part of its Hollywood/FX series.

● COLOR–COMPENSATING FILTERS

Both color-correction and light-balancing filters adjust the proportion of yellow/red to blue/cyan in the light, either absorbing blue/cyan or yellow/red. Their effect is fairly broad across the visible spectrum.

Sometimes it is useful to be able to target more specific areas of the spectrum, because imbalances can occur in the proportion of all components of incident light. These imbalances are corrected by color-compensating filters, which can also give a photographer precise control over the creative color rendering of the subject.

Color-compensating filters are available in seven strengths, in both the additive and subtractive primary colors as shown in the charts on page 72. These charts also give the approximate exposure increase each re-

quires. Having the filters available in both the additive and subtractive primaries often allows two filters to be replaced by a single one, keeping the number of filters that are placed in front of a lens to a minimum. For instance, if the photo calls for both a CC10Y and a CC10M, a CC10R can be substituted to give the same result (which also saves $\frac{1}{3}$ stop in exposure increase).

As with color-correction and light-balancing filters, the color-compensating series is primarily intended to correct imbalances or deficiencies in the lighting, but color-compensating filters also correct imbalances in the way film responds to exposure. These are all most noticeable in neutral areas on the film.

Where the photographer has control over lighting, such as in the studio, color-compensating filters are often used to fine-tune a specific emulsion of film so that neutrals are correctly recorded. This is done by setting up a test situation like the one

COLOR-COMPENSATING FILTERS

Yellow (Absorbs Blue)	Increase in Exposure (Stops)	Magenta (Absorbs Blue)	Increase in Exposure (Stops)	Cyan (Absorbs Red)	Increase in Exposure (Stops)
CC025Y	0	CC025M	0	CC025C	0
CC05Y	0	CC05M	$1/3$	CC05C	$1/3$
CC10Y	$1/3$	CC10M	$1/3$	CC10C	$1/3$
CC20Y	$1/3$	CC20M	$1/3$	CC20C	$1/3$
CC30Y	$1/3$	CC30M	$2/3$	CC30C	$2/3$
CC40Y	$1/3$	CC40M	$2/3$	CC40C	$2/3$
CC50Y	$2/3$	CC50M	$2/3$	CC50C	1

Red (Absorbs Green & Blue)	Increase in Exposure (Stops)	Green (Absorbs Red & Blue)	Increase in Exposure (Stops)	Blue (Absorbs Red & Green)	Increase in Exposure (Stops)
CC025R	0	CC025G	0	CC025B	0
CC05R	$1/3$	CC05G	$1/3$	CC05B	$1/3$
CC10R	$1/3$	CC10G	$1/3$	CC10B	$1/3$
CC20R	$1/3$	CC20G	$1/3$	CC20B	$2/3$
CC30R	$2/3$	CC30G	$2/3$	CC30B	$2/3$
CC40R	$2/3$	CC40G	$2/3$	CC40B	1
CC50R	1	CC50G	1	CC50B	$1 1/3$

described above, using standardized lighting, gray seamless paper, a Macbeth ColorChecker or gray card and possibly samples of other known colors.

Of course, most photography isn't done in controlled situations. Photographers are frequently required to shoot in locations where they have little control over the lighting. If the existing lighting happens to be incandescent or incandescent mixed with daylight, then light-balancing filters can generally be used to correct those color imbalances.

However, more common in modern buildings are fluorescent fixtures, while industrial and outdoor areas are frequently lit by mercury vapor or sodium vapor lights. These types of lighting do not contain a continuous spectrum of light, so their output cannot be corrected by broadly-acting color-correction or light-balancing filters. Instead, these light sources have strong spikes of output at certain wavelengths. Color-compensating filters can improve color balance with such lighting. Again, it is important to remember that no filter can add wavelengths of light that are not present in the incoming light. Filters can only remove wavelengths in an effort to smooth out the incoming light to match the wavelengths of daylight or tungsten for which the chosen film is balanced.

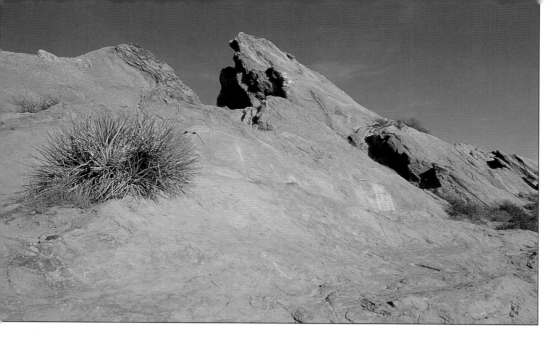

When there is no person or other color reference in the scene, like the rocks in the left photo, even a strongly-colored filter such as a CC30R will give a believable result and can create a more interesting image.

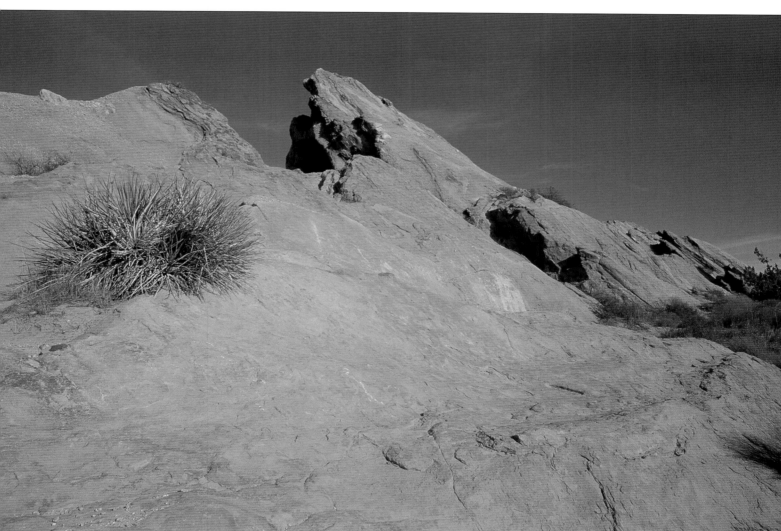

Interior areas lit by fluorescent bulbs record with a greenish cast on daylight film (left photo). A CC30M filter is a good starting point to correct Kodak Ektachrome 100SW when the type of fluorescent bulb is unknown.

Computer screens may look neutral to the eye, but most have a cyan cast when photographed on daylight-balanced film. This can be corrected with a CC30R filter.

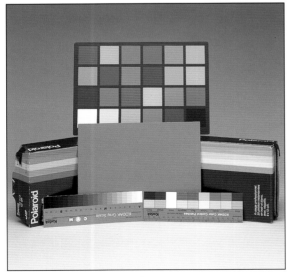

Studio photographers buy large quantities of film at one time and set up a color test under the lighting and processing conditions they normally use in order to ensure that the film will reproduce colors accurately and grays neutrally. Most professional processing labs will read the Kodak gray card and recommend a color-compensating filter correction if one is needed. This emulsion of Kodak Ektachrome 100S needed a CC05C filter to achieve a neutral balance with my Balcar studio strobes.

The tables found on this and the following pages list the color-correction filters suggested by manufacturers to balance their films to fluorescent, mercury vapor and sodium vapor lights. While the correction is quite good under fluorescents, it is less satisfactory under mercury vapor and quite poor with sodium vapor lighting. Filter packs suggested by color temperature meters will generally differ from these recommendations because they will take into account any other light sources in the scene, as well as the changes in output of the lamps with age. This is why professional photographers rely on their calibrated color temperature meters for tricky lighting situations.

Glass filters are available from a number of manufacturers that are designed to correct for the incomplete spectrum of fluorescent lights. Some are designed to correct fluorescents to daylight film. They're basically a CC30M. Others correct fluorescents to tungsten film. They are CC30R filters. Other manufacturers offer filters designed for correcting specific types of fluorescents, such as daylight or cool white to daylight film. While these filters are an excellent choice for photographers who would only have occasional need for them, they will seldom give as accurate color as the color-compensating filter pack recommended by the film manufacturer.

Photographers who shoot architectural interiors and exteriors often have to deal with a number of different light sources in the same photo. In this type of situation, the only way to attain perfect color balance, the way the eye sees the scene, is to expose each source separately, with its required filtration, on the same frame (or sheet) of film. Suppose, for example, that with a building exterior, an exposure is made at dusk with the sunset sky behind the building and all of the building lights off, so that it is a silhouette. Next, without changing anything other than exposure settings and filters, a second exposure is made after dark with the building lights on and the sky black. Unless multiple cameras are used, this gives one exposed frame, so tests are generally made the day before to ensure both accurate exposure and color balance.

Building interiors require a separate exposure for each light source. If daylight is visible through windows, one exposure is made for just the exterior light, usually overexposing a stop or slightly more. Then, without moving anything, the interior lights are turned on after dark, one type at a time, the exposure and filter pack are adjusted and each type of light is exposed.

Filtration for Agfa Film	
Fluorescent Type	**Type RSX II 50, 100, 200**
Daylight	50R +1
White	40M +$^2/_3$
Warm White	40M+10Y +$^2/_3$
Warm White Deluxe	
Cool White	20C+40M +1
Cool White Deluxe	
Unknown Fluorescent	

Fluorescent Type	Velvia (RVP)	Provia 100F (RDP III)	Provia 400 (RHP)	Astia (RAP)	64T (RTP II)	Color Negative (NPH and NHG)
Daylight	40R+10M $+1^{2/3}$	30R+10M $+1$	40R+05M $+1/3$	35R $+1$	85B+40R $+1^{1/2}$	30R $+1$
White	40M+10B $+1^{2/3}$	25M+20B $+1$	40M+10B $+1/3$	15M+20B $+1$	85B+81D+40B+10M $+2^{1/2}$	10C+20M $+2/3$
Warm White	80C+25M $+2$	80B+15M+10R $+2/3$	80C+20M $+2$	80B $+1/3$	30R+05M $+1$	30B $+1$
Warm White Deluxe						
Cool White	40M+05R $+1^{1/3}$	35M $+1$	30M+10R $+1/3$	30M $+2/3$	85B+25M+10R $+1^{1/2}$	20M $+2/3$
Cool White Deluxe						
Unknown Fluorescent						

Published from information provided by Fuji.

Kodak Negative Film

Fluorescent Type	Portra 160NC, 160VC, 400NC, 400VC	Portra 800	Supra 100	Supra 400	Supra 800
Daylight	20R+05M +1	40R +1/3	40R +1/3	30R+05M +1/3	40R +1/3
White	40B+05C +1 2/3	30C+40M +1 2/3	30B+10M +1 2/3	30C+40M +1 2/3	30C+40M +1 2/3
Warm White	40B+40C +2	50B+05C +2	50B +2	60B +2/3	50B+05C +2
Warm White Deluxe	40B+50C +2	40B+40C +2	40B+40C +2	55B+40C +2/3	40B+40C +2
Cool White	30B +1	30M +1	30M +1	05C+30M +1 1/3	30M +1
Cool White Deluxe	40C+10M +1	20B+20C +1	20B+20C +1	20B+20C +1 1/3	20B+20C +1 1/3
Unknown Fluorescent	40B+40C +2				
High-Density Discharge Lamp					
High-Pressure Sodium Vapor (2700 K)	50B+70C +2 2/3	60B+50C +2 2/3	55B+50C +2 2/3	55B+50C +2 2/3	60B+50C +2 2/3
Mercury Vapor	30B+05C +1	30M +1	30M +1	20B+30M +1 2/3	30M +1
Metal Halide (4300 K)	05C+10M +1 2/3	05R+20M +1	50R+20M +1	30M+05Y +1 1/3	05R+20M +1
Metal Halide (3200 K)	80C+10M +1 2/3	20B+30C +1 2/3	50C+20M +1 2/3	30B+05C +1 2/3	20B+30C +1 2/3

Published from information provided by the Eastman Kodak Company.

Fluorescent Type	Kodachrome 25, Ektachrome EPP, E100S, E100SW, 100VS, E200	Kodachrome 64	Kodachrome 200	Ektachrome 64T
Daylight	50R +1	50R+10M +1⅓	30R +⅔	85B+40M+30Y +1⅔
White	40M +⅔	05C+40M +1	10B+05M +⅔	5R+10M +1⅔
Warm White	20C+40M +1	20B+20M +1	40B+05C +1⅓	50M+40Y +1
Warm White Deluxe	30B+30C +1⅓	40B+05C +1⅓	10B+50C +1⅓	10R +⅓
Cool White	40M+10Y +1	40M+10Y +1	20M +⅔	60R +1⅓
Cool White Deluxe	20C+10M +⅔	05B+10M +⅔	05B+20C +⅔	20M+40Y +⅔
Unknown Fluorescent	30M +⅔	05C+30M +1	10B+05C +⅔	50R +1
High-Density Discharge Lamp				
General Electric Lucalox *	80B+20C +2⅓	70B+30C +2⅔	50B+70C +2⅔	50M+20C +1
General Electric Mercury Vapor	20R+20M +⅔	30R+10M +1	20R+10M +⅔	60R+20Y +1⅔
Deluxe White Mercury	30R+30M +1⅓	30R+30M +1⅓	10R+30M +1	70R+10Y +1⅔
Clear Mercury	70R +1⅓	120R+20M +3	110R+10M +2⅔	90R+40Y +2
* High Pressure Sodium				

Published from information provided by the Eastman Kodak Company.

Obviously, when taking multiple exposures on the same frame or sheet of film, it's important that the camera itself isn't moved at all. Even the slightest movement can destroy the shot.

Sometimes light "sources" are not conventional light sources at all. When photographing a computer monitor or television screen, cathode ray tubes (CRTs) become light sources in the photo. On daylight-balanced film they are overly blue-green, requiring CC30R filtration to correct the colors. When the lighting can be controlled, one exposure is made for the scene with the CRT off, using whatever filters are needed to properly balance it. Then a second exposure, on the same frame, is made of the CRT using the CC30R filter with the scene lights off.

With all the care taken by photographers to correct their film during exposure, it may still come back from the lab with a color cast due to processing variations. Some labs processing color transparency film intentionally run a warmer or cooler color balance because the majority of their customers prefer the look of their film this way. Customers who prefer a different balance have to make adjustments with color-compensating filters.

Even the film may be slightly out of balance. While transparency films for professional photographers are only released for sale when they meet stringent color balance tolerances, amateur films are not given such close scrutiny, and may require color-compensating filters to adjust their balance. This is why the tables published in this book list only professional films—their initial color

balance is carefully controlled, so there is a known baseline from which to make adjustments. But even professional films, if incorrectly stored or outdated, can require color-compensating filters to bring their balance back to neutral.

Used creatively, the stronger color-compensating filters can be used much like the color-correction or light-balancing filters to create "mood," or an almost monochromatic effect by tying foreground and background together with color. The range of colors is far greater, however, with color-compensating filters. The stronger filters are also effectively used to increase the color saturation in an already monochromatic scene. Taking a close-up photo of a red rose with a CC30R filter will dramatically saturate the color of the rose and minimize any small color defects it might have.

The weaker color-compensating filters can be used to subtly intensify a color by using a filter the same color as the subject, or subdue color by using a complementary filter, while having little effect on highlights and shadows. The color of a pale yellow flower against a white fence will seem more intense when photographed with a CC10Y filter, or even paler with a CC10B, but the fence will still look white to the eye. Only by laying the two slides together on a lightbox will the effects of the filters on the fence be obvious.

Color-compensating filters are usually purchased as gelatin or polyester because many photographers carry a large number of them. They are also available in resin or glass from some manufacturers.

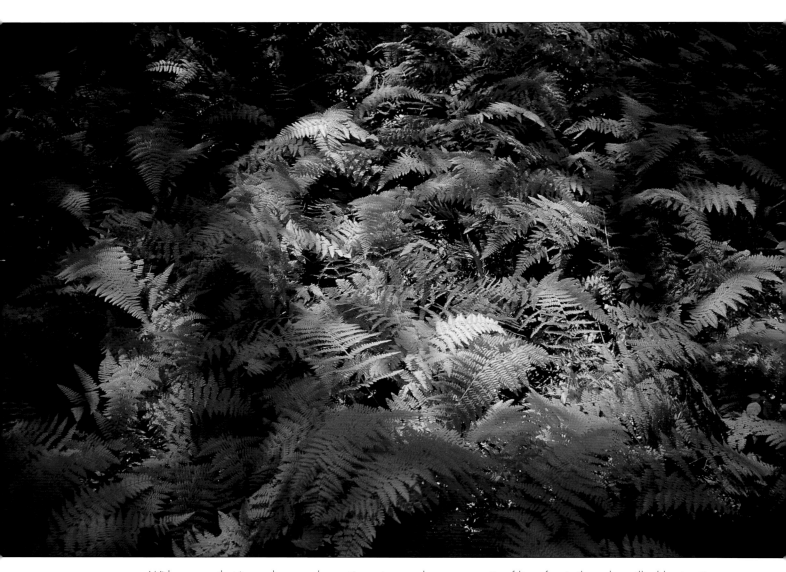

With a scene that is nearly monochromatic, a strong color-compensating filter of a similar color will add saturation, as in this photo of ferns taken with a CC30G filter.

Color-conversion, light-balancing and color-compensating filters are readily available in all forms: gelatin, polyester (mounted and unmounted), resin and glass (uncoated, coated and multicoated).

● BLACK & WHITE FILTERS WITH COLOR FILM

Just as it's possible to use color filters with black & white film, it's also possible to use black & white filters with color film. This effect was briefly mentioned at the beginning of the previous chapter. Because of the deep colors of the filters, this can be a heavy-handed approach. The final image will clearly be recognizable as unreal and manipulated, so there must be a strong creative reason for doing so.

One reason might be to instill a mood that is beyond anything that the average photog-

By combining exposures through filters normally used with black & white film, it is possible to create special-effect photos like this one.

rapher might experience, such as intense heat or extreme cold. To instill a feeling of heat, a #25 filter would be used. To instill a feeling of cold, a #47 filter would be used. Another reason could be to create an image so abstract that only the graphics are important, such as a monochromatic silhouette.

The motivation behind such use might also be to create a special-effects image, to make the viewer wonder "How was that done?" or "What is the photographer trying to say?" or simply "That's beautiful." For example, if successive exposures are made on the same frame through a red #25 filter, a green #58 filter and a blue #47 filter on color transparency film, a natural-color image will be produced, as if no filters were used. However, if any part of the scene moved during the exposures, it will be recorded as

red, green or blue in an otherwise "natural" photo. Clearly, that trick could lead the viewer to ask, "How was that done?"

Many filters are available to the experimenting photographer to create special effect photos. Some are so commonly used they might hardly be considered "special effects."

Others are used only rarely because the effect so obviously cries "special effects filter."

The next chapter will look at many of these filters and their uses.

CHAPTER 5

FILTERS FOR SPECIAL EFFECTS

Up to this point in the book, the focus has been primarily on the use of filters as corrective tools in photography. But the same filters are also very effective creative tools. All it takes is a little experimentation to discover many ways to utilize them creatively.

There are also a large number of photographic filters designed specifically to produce certain types of special effects. Many of them can be utilized both for black & white and color photography, while others are most commonly used for color work. With the wide range of special effect filters available, it's difficult to classify them into neat categories. Arbitrarily grouping such filters into different categories is counterproductive anyway, since that goes against the whole concept of "creativity," which often involves breaking rules and ignoring classifications.

The only reasonable system to categorize filters is to group them by the effect they are designed to produce. Some groups include a large selection, others only a few.

It's also important to realize that most of these filters can be used in combination with others, either correction filters from previous chapters or other special effect filters. While a variety of filters are covered, this chapter is intended more as an introduction to what is available than a textbook on applications. Their appropriateness in any given situation is part of the creative decision-making process photographers undertake as they're working.

● SOFT FOCUS, DIFFUSION AND FOG FILTERS

Soft focus, diffusion and fog softening filters are so widely used by photographers of all specialties that it is difficult to think of them as special effect filters at all. In their simplest forms they can be custom made by the photographer right before the exposure. Breathing on the lens, or smearing petroleum jelly or even oils from the cheek or nose over a UV filter are long-standing, but unfortunately, not very repeatable ways of softening a photo.

Portrait photographers in particular may well consider soft focus filters to be "correc-

tive" filters, but correcting for imperfections in their subjects' skin rather than in color balance of the light. All of the filters in this group do indeed soften the sharpness of modern lenses as well as lowering, to a lesser or greater degree, the contrast of an image.

Softening filters can be grouped into four different types according to their design. The first type has a random pattern of waves, bubbles, dimples or tiny lens elements in the

filter. The second has a regular pattern of concentric circles or dimples. The third type has an overall texture to it and the fourth has a net or random black pattern. Grouping softening filters by design and construction avoids the sometimes confusing and non-standard designations of "soft-focus," "diffusion" and "fog" filters given by their manufacturers.

The first type of softening filters, those that incorporate random elements, achieve their

Cokin Dreams filters produce a sharp image surrounded by a soft halo of light. This is achieved by adding a pattern of simple lenses in the center of a piece of clear resin, producing an effect similar to spherical aberration. A photo taken with Dreams 1 (091) is on the left and Dreams 3 (093) is shown above.

effect by refracting some of the light passing through them. In order to better understand how this is done, it is important to understand how the lens forms a sharp image.

When light passes through glass or most any light transmissive substance, it travels more slowly than when it travels through air. The speed of light in air divided by its speed in

glass is the index of refraction of the glass. This index of refraction also measures how much the light is bent, or refracted, as it enters and leaves the glass.

The ideal photographic lens would bend all of the entering light rays so that they would all come to focus at the film plane at the same time. Light that is not brought to com-

plete focus degrades the sharpness of the image, much like manually defocusing the lens. Because of several defects or aberrations inherent in all lenses, the ideal photographic lens is difficult to achieve.

For example, all wavelengths of light are not refracted equally. Blue light is bent more than red, so it is brought to focus closer to the lens than red light. This effect, called chromatic aberration, is the reason that photographers must manually adjust the visible light focus to a different setting on the lens when shooting infrared film. Chromatic aberration, if uncorrected by using glasses of different refractive indices, would result in subjects whose colors are blurred. Apochromatic lenses are corrected to bring red, green and blue wavelengths to a common focus with negligible chromatic aberration.

When light enters a simple curved glass lens, the amount it is refracted also depends on the angle at which it strikes the lens. Light entering near the center of the lens is refracted less than light entering at a greater angle near the edge of the lens. The light that entered the lens near its edge is focused slightly closer to the lens than light entering near the center. This effect is called spherical aberration and is minimized in modern lenses by using lens elements of different shapes (concave and convex) in combination, or by using aspheric lens elements.

Spherical aberration can be left uncorrected or not fully corrected and produce an image that is both a sharp image and has a soft gradation throughout. This is exactly how portrait lenses available from some manufacturers are designed. The amount of softness is controllable by varying the aperture of the lens—as the lens is stopped down to smaller apertures, a greater proportion of the light entering through the center of the lens is used to form the image and the image is sharper than when the lens is used at maximum aperture.

It isn't necessary to invest in a specialized lens, however, to come up with a professional-looking soft focus effect. Some of the most popular types of soft focus filters, those in the first group, are designed to give a very similar effect. The filter is clear glass or resin with a random pattern of tiny lens-shaped elements in it, looking like drops of water or a hammered surface. The clear areas allow light to pass and form a sharp image, while the rest of the filter refracts light to create a soft secondary image. Filters of this type were originally created by Zeiss as the Softar filter and are still available.

Other manufacturers have similar filters available with bubbles, dimples, waves or other irregular patterns. Unlike portrait lenses, the softening effect is most pronounced in areas of high contrast, is independent of aperture and makes for much easier focusing with the lens wide open. Several strengths are available in each type of pattern.

Different softening effects can be achieved with filters of the second type, which incorporate a regular pattern into the filter. Concentric circles or regularly-spaced dimples create a soft halo around the highlights

No filter

Tiffen Soft/FX 2

Tiffen Soft/FX 3

Tiffen Warm Soft/FX 3

Tiffen Pro-Mist 2

Tiffen Pro-Mist 3

Tiffen Warm Pro-Mist 2

Tiffen Black Pro-Mist 2

Softening filters are often used in portraiture. These examples show a few of the effects, which vary from very subtle to very soft, available in the Tiffen line of filters. With the enormous number of softening filters available from many manufacturers, deciding on which type to use is a difficult task. It is best to select a type of softening, then buy the full range of strengths available in that type.

with only a hint of softness that can be minimized by stopping down the lens. Filters with other regular patterns are also available. These also act primarily on the highlights while midtones and shadows are less affected. Tiffen's Soft/FX series, for example, is available in five strengths. With its coral-colored 812 warming incorporated, an additional five strengths are available as the Tiffen Warm Soft/FX series.

Depending on the pattern, some effects vary with lens opening and others don't. All of these filters utilizing light refraction leave some of the image sharp throughout the photo while creating a glow around the highlights.

While softening filters in the first two types are designed to leave some of the image sharp, those of the third type produce an

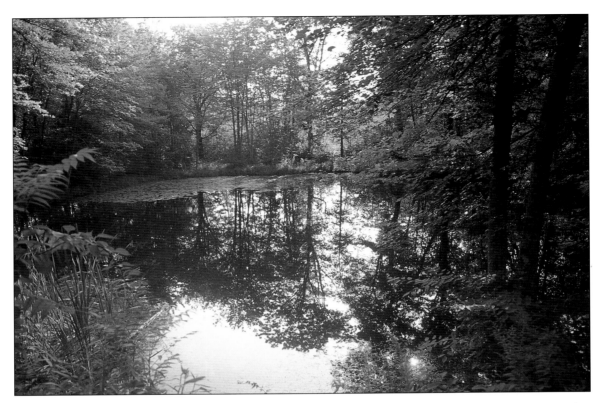

overall, even reduction in sharpness. Filters in this group look and act much like a lens that has been breathed on. They are available in a range of strengths from each manufacturer to provide slight to considerable softening of the photo. Along with softening, these filters also diffuse the image, lowering the contrast in varying degrees. They go by the names "diffusion," "fog," "mist" and sometimes "soft focus." However, some manufacturers even label softeners of the pattern types "diffusers," though they do little to reduce image contrast. That just goes to show that names can be deceiving.

While the pattern-type softeners lower contrast primarily in high contrast areas, bleeding highlights into dark areas, overall softeners lower contrast throughout the image. The strongest of these are generally the

"fog" filters. They are capable of veiling the entire photo in a white haze simulating real fog. Backlighting, early morning light and a wide aperture enhance the effect. Combining several together intensifies the effect even more. Using such filters without a lens shade also increases the degree of diffusion.

Several manufacturers produce fog and mist filters with the diffusion over just half or less of a rectangular filter, allowing the transition line to be adjusted to a position other than the middle of the frame. A mist filter with clear ends cut by a band of diffusion that can

Graduated fog filters can make a fogless scene, like the one above, appear to have a covering of ground fog (facing page, top) by using the filter over the lower part of the scene. They can also give the feeling of fog lifting from the scene (facing page, bottom) by using the filter over the upper part of the scene.

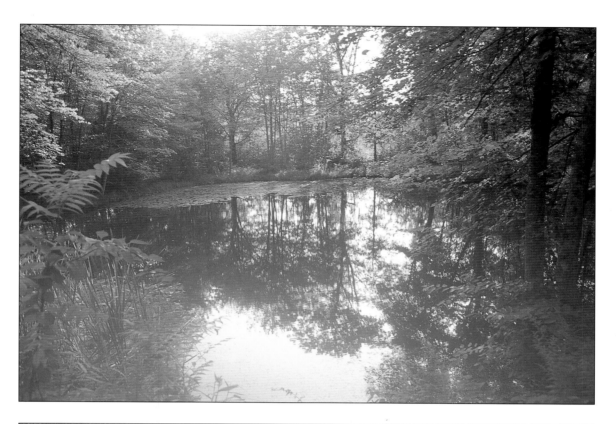

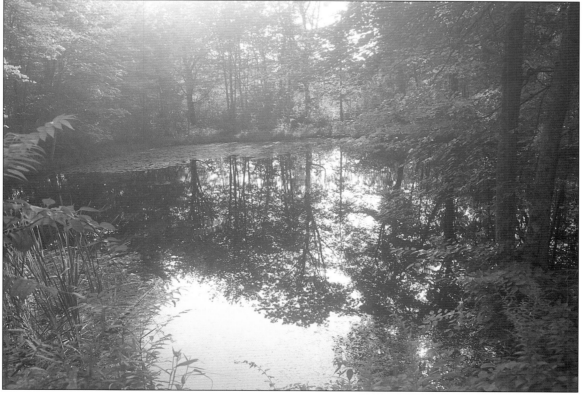

Split diffusion is a technique that produces a sharp image with softened highlights, as in this image. One exposure was made without a filter using only the fill light. Then a softening filter was added and another exposure was made using the main light. For portrait subjects, a device called a Turbofilter can be used. The Turbofilter rapidly spins three filters (one clear and two softening) in front of the lens and fires off power packs at appropriate times when the filters are aligned with the lens.

be positioned anywhere in the frame is also available.

To draw attention to the main subject and minimize distracting elements around it, filters with a clear central area and diffusion surrounding it are available from many manufacturers. This style filter is popular with wedding photographers and is often used when photographing the bride and groom together, or the wedding ring on the bride's hand.

Overall softening filters are also available that mimic an old Hollywood technique of stretching a nylon over the movie camera lens. This fourth type of softener contains a net material laminated between clear optical glasses. Black netting provides softening with little reduction in contrast. White netting softens and diffuses the image. By incorporating different spacing in the netting, manufacturers produce filters of this type with varying degrees of softening.

Many manufacturers have their own unique sets. Lee Filters' "Net Set" consists of two black, one white and one flesh-colored net-type filter. Each has a clear area that is offset in the rectangular filters so that it can be positioned somewhere other than the center of the frame, or out of the frame completely. Harrison and Harrison offers a unique matched set of Black Dot filters giving five degrees of softening without reducing contrast. Widely used in the film industry for softening, they appear to have a black pattern randomly splattered over their surface. Unlike other softening filters, all of the net and dot filters require a slight exposure increase.

Overall softening filters in the last two groups can be used to simulate the effect of sharp areas/unsharp areas in the same photo with a technique called split diffusion. This requires double exposing the film, with one exposure made without the filter and a second exposure made through the filter. This is most effective in the studio where a portion of the subject, or the background, is shot with heavy diffusion on the lens, and then with the filter removed, another light exposes the subject in sharp focus. Portraits can be done in this way if the filter is removed quickly enough so that the subject doesn't move between exposures.

The softening effect of any of these filters is dependent on several factors; performance cannot be gauged in simply selecting a filter from a specific group. Of these, lighting is by far the most important variable, but subject size and even film contrast play a role.

With low contrast lighting, such as portraits under an overcast sky or lit in the studio with a broad light source, the transition from lighter to darker areas is already soft. Adding a softening filter will smooth this transition further. With higher contrast lighting, a stronger softening filter is required to give the same visual softening to the highlight/shadow transition. However, strong backlighting in outdoor portraiture and land-scape photography calls for less softening since the subject contrast is usually low, even though the scene contrast can be quite high.

Similarly, film of higher contrast, like color transparency film or slow-speed black & white emulsions, require a stronger softening filter to produce an image similar in softness to that from a color negative or high-speed black & white film.

The size of the image in the frame is also an important consideration. For a consistent look, a frame-filling headshot requires more softening than a full-length portrait. This is partially due to the amount of background visible. A white or light background will diffuse into the full-length subject, lowering contrast and increasing apparent softness with most diffusion filters. With a portrait filling the frame, little or no background is seen. However, even with a darker background, less softening would be required in the full-length shot.

Because of factors like these, each style of softening filter is made in different strengths. No one single filter will give con-

sistent results in a variety of real-world situations. It is best to find a style that produces the desired effect and purchase the full set of strengths in that style. This will produce similar results in a variety of lighting situations, or a variety of results in the same lighting situation.

Counting all of the various types, strengths, warmths and sizes of softening filters, there are more than a thousand choices available. Unfortunately, it's only possible to show samples of a few of them here.

● CONTRAST FILTERS

Excessive contrast is a common problem in outdoor photography. It isn't always possible to photograph only within two hours of sunrise and sunset. At other times during the day, a decision must be made to expose for the highlights or the shadows and let the other end of the scale go. With transparencies, this will result in severely over- or underexposed areas of the film. Soft-focus filters will lower contrast, but with greatly decreased sharpness. What is needed is contrast reduction without loss of sharpness.

Tiffen, as part of its Hollywood/FX line, produces several filters that lower contrast without flare and loss of sharpness. The Ultra Contrast opens up shadow areas and reduces contrast throughout the image.

FACING PAGE: Reducing the overall contrast of a scene without affecting sharpness is possible with several filters from Tiffen's Hollywood/FX line. The Ultra Contrast used to make the photo on the bottom opens up the shadow side of the vertical white post and gives more detail in the deep shadows in the background when compared to the photo taken without a filter (top).

The Low Contrast brings detail back in the deepest blacks of the shadows and creates muted pastel colors, while the Soft Contrast darkens highlights and opens up shadow detail.

● GRADUATED FILTERS

Graduated neutral density filters were discussed in chapter 3 as a way to preserve cloud detail in landscape photography by lowering the sky exposure to more closely match that of the foreground. But if the sky is an even overcast, neutral density filters only render it as a darker gray.

In the studio, ND grads can gradate a white seamless paper backdrop to light or dark gray, but they don't have any impact on color. If the scene has to go from one color to another, such as from white to blue, color graduated filters are required.

First introduced by Cokin in the 1970s, color-graduated filters quickly found a market with advertising and automobile photographers. They allowed the introduction of color into the background or sky of the softly-lit images popular during that time.

Graduated blue filters can change an overcast gray sky to a rich blue. With the gradation reversed, the same filter can turn a dull gray ocean blue. A red, coral, orange or yellow grad can turn an overcast sky in the same shot into a sunset. Location car and motorcycle photographers have used the tobacco grad to color the post-sunset sky behind the car to the point of it becoming a cliché. Unfortunately, many of these shots scream out "graduated color filter used here."

Graduated filters are available in a wide variety of styles and colors. The examples from Lee Filters in the left photo show soft and hard gradations, stripe filters that are particularly effective at the horizon, and only a few of the colors available. Lee also has graduated filters available in sets, such as the three filters in the Sun Set shown in the right photo.

For a more subtle effect, graduated filters can be used to increase the color saturation in the area covered by the filter. Blue grads over blue water, sunset grads over a sunset sky, light chocolate or coral grads with autumn colors, pink stripe grads at the sunset horizon—these are just a few ways to use these filters to intensify colors similar to their own without calling attention to the fact that a filter was used at all.

Graduated color filters are used effectively with neutral density grads where the ND grad is positioned to darken just the very top or very bottom of the area covered by the color grad. Using offset complementary-colored grads has a similar effect, such as darkening just the upper portion of the blue-grad covered sky with a tobacco grad filter.

There are numerous colors and densities available in graduated filters from various manufacturers. Most color grads are rectangular to allow the transition area, which can

be gradual or abrupt depending on the design, to be positioned anywhere in the frame. These require a filter holder and adapter ring like all rectangular filters. A few are available as rectangular glass models, and even multicoated glass at a premium price, although most color grads are made of resin. Multicoated glass filters are well worth the price when shooting sunsets, as the improvement in image quality is noticeable.

Whether used for obvious enhancement or a subtle increase in saturation, color-graduated filters offer a multitude of creative possibilities. What they can't do is to "pump up" certain colors in the scene while retaining a reasonably accurate color rendering. That's where the next group of special effect filters comes in.

● ENHANCING FILTERS

If the Grand Canyon or the fall foliage colors never seem as intense on film as you would like them, then enhancing filters are

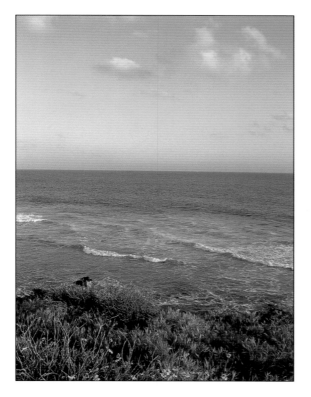

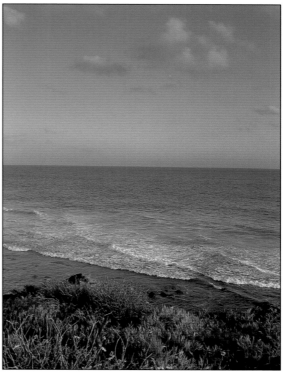

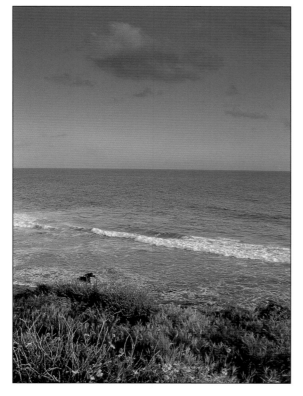

A graduated neutral density filter can be used to bring the brightness range of the scene within the range that film can record. Lee Filters makes these filters in several strengths, here lowering the sky exposure of the original scene (top left) by one stop (top right) and two stops (left).

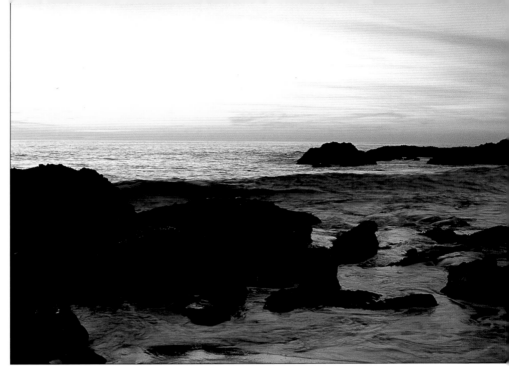

Cokin Sunset graduated filters are unique in that they have no clear, uncolored area. Rather, they gradate from a lighter to a darker value of the same hue. Here a Sunset 2 (198) is combined with neutral density filters to enhance an otherwise ordinary sunset.

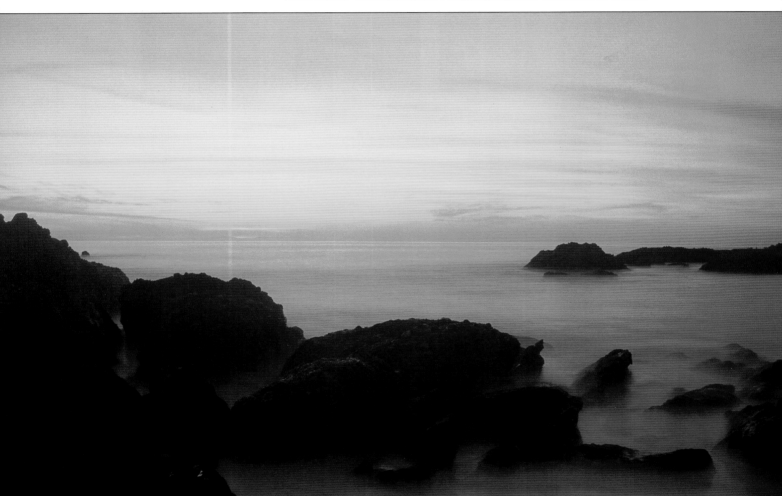

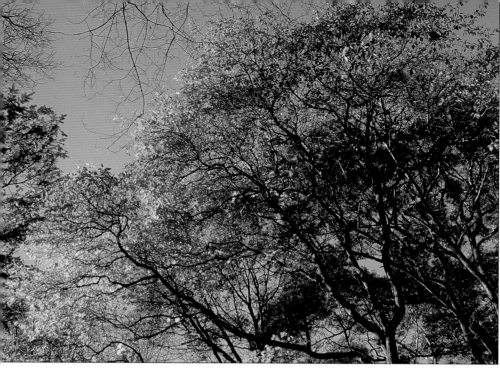

Enhancing filters selectively intensify certain colors while leaving others relatively unaffected. Here, a Lee Enhancer, which effects the reds and oranges most strongly, is used to photograph fall foliage. Other enhancing filters are available for blues and greens. (photo by Amelia Sholik)

the answer. Also known as intensifying or didymium filters, they are made of glass blended with rare-earth elements that selectively transmit and absorb specific wavelengths of light. The original and still most common type enhances reds, oranges and yellows. Models are available from a number of manufacturers, including Tiffen, the originators. Recently other suppliers, Singh-Ray in particular, have introduced intensifying filters for greens and for blues. Enhancing filters are also available in combination with a polarizing filter.

Effectively using enhancing filters requires experience. They're certainly not for anyone looking for "accurate" color. It is a good idea to practice using these filters to get a

feel for the effects they produce, so be sure to shoot the same scene with and without an enhancing filter. The effect an enhancing filters has on a captured image must be reviewed and judged on the lightbox. The effect can be quite different than it appears through the lens.

A blue enhancing filter combined with a polarizer, available from Singh Ray, adds impact to this marine scene, shown without filter in the smaller image.

Enhancing filters are not to be confused with the "warming" filters discussed previously. Their effect is not uniform across the spectrum. Those that intensify reds the most, for example, tend to give a magenta cast to neutrals and to desaturate greens, while those that give less enhancement have less effect on neutrals or other colors. Using the enhancing filter in combination with a polarizing filter restores some of the saturation lost to the enhancing filter's complementary colors, but requires a significant amount of exposure compensation.

The degree of enhancement that the filters create is also dependent on the subject and film. Any color can only become so saturated on any particular film. Therefore, colors that are less intense to begin with will show more of a gain in saturation than the more intense colors in the scene. Although these are some of the most expensive filters available, their ability to intensify certain colors without forcing an overall change is worth their expense.

● STAR AND DIFFRACTION FILTERS

From simple four-pointed stars, to asymmetrical sixteen-pointed patterns, to rotating plates of etched glass capable of a multitude of star effects, these filters have been used extensively by still, motion picture and television camera operators to add sparkle to point light sources in their images. They are particularly effective in city scenes at dusk, or anytime there are a multitude of small, bright light sources and a darker background. To add a highlight to their otherwise softly-lit product photos, studio photographers will double-expose the film with a star filter and a strategically placed grain-of-wheat bulb.

Star filters are made from glass or resin that has been etched in a fine grid pattern. The depth, spacing and pattern of the grid determine the star pattern. Most star filters have the pattern evenly distributed over the entire surface, although Lee Filters offers models with the pattern in only a section of the filter so that it can be positioned in the frame to give stars in some areas but not others. The size and intensity of the light source as well as the darkness of the surroundings and the lens aperture used affect the final result. The filters themselves require no adjustment in exposure.

All star filters cause some flare, resulting in lower image contrast. In some cases, that's acceptable, even desirable, since they are often used in high-contrast situations. It also makes star filters useful substitutes for soft-focus filters in portraiture, adding a subtle star to the highlight in the eye. Flare is greatest with those resin filters that produce closely spaced stars of multiple points.

When the intensity of the light source is high enough, star filters can produce a rainbow effect at the tips of the stars. This effect can also be produced by etching glass with thousands of fine lines per inch or incorporating millions of tiny microprisms in the glass. Filters of this type, called "diffraction filters" are available in many styles. All of them break the light from light sources or specular reflections in the photo into a spectrum. The spectrum takes the shape of a line, star, circle or even a square centered on the light

No filter

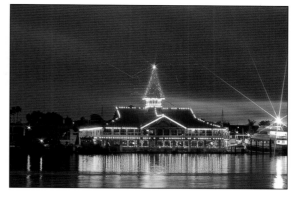

Tiffen Vector Star

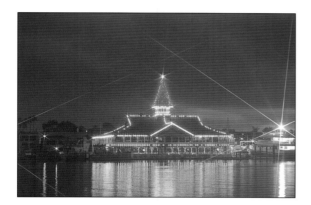

Cokin 056 Star 8

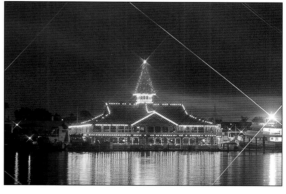

Hoya 4-point Star

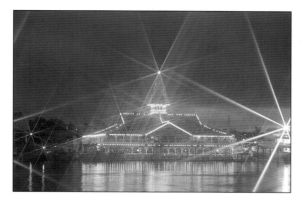

Kalcor 6-point Star

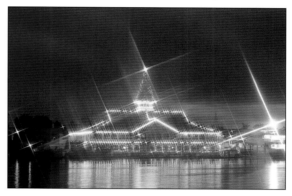

Custom 4-point Star

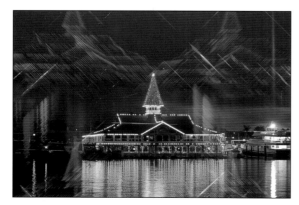

Diffraction grating

Star filters are available in a wide variety of styles and effects. Some have no effect on the sharpness of the photo while others diffuse the image along with making a star over the light sources. The Custom 4-point Star filter was specially made from finely etched glass for my commercial photos where no loss of sharpness was acceptable. These images illustrate the effects achieved with various star filters. The image on the facing page was made with a diffraction filter. (photo on facing page by Ron Eggers)

source. Diffraction filters are also available with a clear central area so that the subject is unaffected but surrounded by a multi-colored array of light. Flare can again be a problem, but the diffraction filters, even more so than the star filters, are most effective with light sources surrounded by very dark areas. This tends to minimize the effect of contrast-reducing flare.

⦿ MULTI-IMAGE AND DOUBLE-EXPOSURE FILTERS

Sometimes a single image of a subject isn't enough. For those occasions, photographers can use multi-image and double-exposure filters.

Multi-image filters consist of several glass surfaces of different shapes and positioning. All are designed to produce multiple images of the subject during a single exposure. Some produce a central image surrounded by repetitions, others produce a number of repetitions without the central image.

Still others produce a series of parallel images with the subject reproduced fully in one image and partially in others. Several multi-image filters are available with color foils beneath the prisms, resulting in multi-colored multi-images.

Using multi-image filters with wide-angle lenses tends to crowd the images too closely together; therefore, normal to telephoto lenses are recommended. It's also a good idea to use large apertures to blend the images better, and employ dark, simple backgrounds so that the images don't wash out when overlapped. An exposure adjust-ment is necessary when using the colored multi-image prism filters, but none is required with the clear filters.

There are times when the same image has to be repeated on the same piece of film, but in different positions. For instance, a portrait of a subject might include both a straight-on view and profile view of the same subject. That's easy enough if the background is totally black. It can be handled as a simple double exposure by carefully positioning the subject each time. That, however, doesn't work with a white or light background. Doing a simple double exposure would cause each of the images to wash out when the other exposure was made.

Double-exposure filters are available to make such photos possible. One half of the filter is completely black and the other is clear. With the camera on a tripod, attach the filter and make the first exposure with the subject positioned in the clear area. Use the metered exposure, either measured before the filter is attached or with a handheld meter. Then rotate the filter exactly 180°, reposition the subject in the clear area and make the second exposure at the same settings as the first. The result is a photo with the same subject in two positions on the same frame on a white (or any other) background.

⦿ POP FILTERS

Both chapter 2 and chapter 4 briefly mentioned the use of strongly-colored Wratten filters designed for filtering black & white film to achieve special effects with color film. Filters in colors other than those available in Wratten colors are also

Multi-image filters create multiple images of the main subject in a circular pattern, as seen here, or in a repeating parallel pattern. When used with wide-angle lenses, the images are grouped tightly together. The longer the focal length of the camera lens, the greater the separation between images. (photo by Ron Eggers)

available. They're generally called "pop" or "fantasy" filters by their various manufacturers, and are available in pink, purple, violet and orange as well as red, green and blue.

Like the black & white Wratten filters, they are most effective with simple graphic shapes and in situations where the scene is fairly monochromatic to begin with. Examples might be figures against a dark background or silhouettes against the sky. Many have very high filter factors that differ for daylight or tungsten-balanced films. Interesting effects can be achieved by using one of these filters with tungsten film in daylight or daylight film with tungsten lighting.

Filters in "pop," "fantasy" and other colors are also available with a clear central area. These Colorspot filters are made of glass or resin with a hole in the center to allow the subject to be photographed in actual color surrounded by a halo of filter color. The wider the lens aperture, the softer the transition from clear area to color area. And the longer the focal length, the larger the clear central area.

That's only a small sampling of the different types of lens filters on the market, and more are coming onto the market all the time. They offer exciting possibilities for the creative photographer. They expand the opportunities to express individual vision and style. Used alone or in combination with other techniques, they make it possible to create effects directly onto film that are both interesting and unique.

CONCLUSION

While this book primarily considers the use of lens filters, there are other ways to use filters in photography. For example, as touched on previously, lights can also be filtered. Obviously, the square or circular filters that fit over lenses won't work.

Many of the neutral density, polarizing, color-conversion, color-balancing and color-compensating filters are available from movie and theatrical supply houses in sheets as large as 20x24 inches and rolls as wide as 48 inches. While they are not designed for use over the camera lens, they can be used over light sources. Used in this way, it is sometimes possible to simplify color correction.

There are also times when a combination of lens and light filters can be used to fine-tune a scene's color balance. For example, when shooting in areas lit primarily with fluorescent lights, but with some tungsten fixtures, it is possible to filter the tungsten lights to the same color balance as the fluorescents, then correct them all by placing a filter over the lens to correct the color balance of the film.

When shooting in office situations lit by overhead fluorescents, it is beneficial to use some flash fill on the camera to light people in the foreground. If a CC30 magenta is used on the lens to correct daylight film for the fluorescents, the flash fill will be overly magenta. By covering the flash with a CC30 green filter, which is complementary to the CC30 magenta over the lens, however, the flash will be correctly balanced on the film!

Many photographers use an 81A filter over their portable flash at all times to give a slight warming effect and remove the UV. For these purposes, it is often possible to cut pieces of filters from low-cost sample books available from filter suppliers.

In the studio, using colored gels for lighting effects is standard procedure for many photographers. Warming gels are used over flash heads backlighting portrait subjects. Gels of all colors are used in advertising photography to create lighting effects and lead the

eye to the center of interest. The applications are unlimited once the photographer is comfortable with the technical and artistic use of filters.

Remember, it takes time to master the use of filters, so don't become discouraged if your initial photographs don't meet your expectations. Often, these miscues are part of the learning process that can lead a photographer toward new directions. While it takes a lot of the spontaneity out of shooting, keeping notes of filters and exposures used, at least initially, will speed the learning process and make it possible to recreate the effect in the future. Once the technical aspects of a filter have been mastered, don't let arbitrary rules restrict your creativity.

APPENDIX

Photographers who specialize in a particular subfield of photography generally wind up with a set of filters in their bags that they use regularly. They frequently also end up with a bunch of filters that they've acquired that didn't suit them, but that's part of the learning curve. The following lists offer recommendations for sample filter sets photographers have found useful.

⊙ **LANDSCAPE PHOTOGRAPHERS**
 Skylight or UV filter
 Polarizer
 Neutral density grads
 81-series warming filters
 Enhancing filters
 82A cooling filter
 Wratten 8, 11, 12, 15, 25 filters for
 black & white

⊙ **NATURE AND FLOWER PHOTOGRAPHERS**
 Skylight or UV filter
 Polarizer
 Close-up filters
 81-series warming filters
 Enhancing filters
 82A cooling filter
 Wratten 8, 11, 12, 15, 25 filters for
 black & white

⊙ **PORTRAIT PHOTOGRAPHERS**
 Soft focus and diffusion filters
 81-series warming filters
 Wratten 8 and 11 filters for black & white

⊙ **TRAVEL AND VACATION PHOTOGRAPHERS**
 Skylight or UV filter
 Polarizer
 One- and two-stop neutral density filters
 Neutral density grads
 Color grads
 Sunset filters and sunset grads
 81-series warming filters
 Star filter
 Soft focus filter
 Enhancing filters
 82A cooling filter

GLOSSARY

Aberration—Failure of a lens to produce a theoretically perfect image of a point.

Additive primary colors—Red, green and blue (or RGB) are known as the additive primaries. If equal intensities of these colors are added together, the eye perceives the light as white light. The proper mixing of red, green and blue light in the eye can duplicate any color sensation.

Antireflection coating—A thin layer of material that covers the portion of the lens in contact with air. This coating reduces light reflection, flare, and improves contrast.

Aperture priority—A mode of automatic exposure in which the camera sets a shutter speed that corresponds to the aperture selected by the photographer.

Apochromatic lens—When designing photographic lenses, the designer is mainly concerned about correcting the chromatic (color) aberration for two colors, usually red and blue. Such a design can result in a high quality lens without noticeable color fringes in all but the longest focal lengths. Such lenses are known as achromatic. Eliminating color fringes completely, and producing the best edge sharpness in long focal length lenses, may require a lens that is corrected for three colors, usually red, blue and green. Such a lens is apochromatic.

Autofocus—A camera feature in which a mechanical device adjusts the position of the lens to obtain a sharp image.

Blackbody—A hypothetical object that, when heated, emits a specific radiation curve.

Bracketing—Making a series of exposures that differ from the metered exposure to ensure that one will express the photographer's interpretation (vision) of the scene.

Burning—Increasing the amount of light that hits the photographic paper when making a black & white print. Can be used to add tone to highlight areas.

Center-weighted neutral density filter—Graduated filters are designed for use with specific wide-angle lenses to eliminate the inherent light falloff the lenses produce at the edges of the frame. Lenses where this is most apparent are used with large-format and panoramic cameras. The falloff is gener-

ally about one stop and the filter corrects this so that the exposure is even from corner to corner. In reality, while these filters work, many large-format and panoramic photographers elect not to use them, preferring the slight darkening at the edges to draw attention to the center of the image. Extreme wide-angle lenses for 35mm cameras show this light loss, but to a much smaller degree because of the difference in lens design; therefore, these filters are seldom used.

Chromatic colors—The colors red, orange, yellow, green, blue and violet, which together compose light.

Close-up filters—Used to extend the close focusing distance. They are widely available in sizes to attach to the front of nearly any lens and come in a range of strengths, from 0 to 10, with magnification increasing as the numbers get larger. Close-up filters increase the focal length of the lens without requiring any increase in exposure.

Color balance—A desirable arrangement of colors within an image.

Color-compensating filters—Red, green, blue, magenta, cyan and yellow filters that, when placed on the lens, produce controlled changes in the color balance of an image. Designated by the letters CC.

Color-conversion filters—Strongly-colored filters that correct a mismatch between the color temperature of a light source and the color temperature for which a specific film is balanced. Use of these filters necessitate an increase in exposure.

Color saturation—A description of the purity of a color. As white is added to a pure color, the saturation decreases.

Color temperature—The temperature to which a blackbody must be heated to emit radiation with the observed composition.

Color temperature meter—A device used to estimate the color temperature of a light source. This meter is generally used to determine the filtration that will match the color balance of the light source with that of standard color film types.

Compendium—Lens shade that attaches to the tripod socket or incorporates a camera grip rather than attaching to the front of the lens.

Complementary colors—Any two colors of light that, when combined, include all of the wavelengths of light and therefore produce white light. Color filters have their strongest effect on their complementary colors and the colors that comprise the specific color.

Continuous light source—Natural light source and those artificial sources that rely upon a burning filament. The spectral energy distribution of a continuous source is a smooth curve, meaning that energy is radiated at every wavelength in its spectral distribution range.

Contrast—The difference between the darkest and lightest tones observed. High contrast occurs when there is a great difference (such as the difference between black & white). Low contrast occurs when there is

little difference (such as the difference between medium and light gray).

Contrast filters—A filter specifically designed to reduce contrast without reducing sharpness.

Daylight-balanced film—A color film that is balanced for use outdoors at midday or with a light source with a temperature of 5500K.

Densitometer—Device used to determine the density of a negative. Often used when running exposure tests.

Density—The degree to which transmissive materials (filters/color slides) pass light. Materials with high density pass less light than those with low density. In reflective material, high density areas reflect the least amount of light.

Depth of field—The range of sharpness in front of and behind the focused distance that is considered acceptably sharp in the final image. Depth of field is increased by closing the lens aperture. Depth of field is a calculated figure and not dependent on the lens design.

Diffraction filters—Filters made of etched glass with thousands of fine lines per inch, or those incorporating millions of tiny microprisms in the glass. Although these filters are available in many varieties, all of them break the light from light sources or specular reflections in the photo into a spectrum. The spectrum takes the shape of a line, star, circle or even a square centered on the

light source. Diffraction filters are also available with a clear central area so that the subject is unaffected but surrounded by a multi-colored array of light. Flare can be a problem, but diffraction filters are most effective with light sources surrounded by very dark areas. This tends to minimize the effect of contrast-reducing flare.

Diffuse light—A scattered light quality, like that from the sky on a cloudy day.

Diffusion filter—Filter used to lower contrast between a white or bright background and the subject, increasing the apparent softness in the scene.

Digital camera—A camera where the image is recorded and stored electronically, not on film. Some medium format cameras can be used for digital recording by attaching a digital back instead of a roll film magazine. Only digital cameras that allow the white balance to be set and locked prior to attaching the filter are usable for serious filter photography.

Diopter—Term used to indicate the focal length of a lens, especially in eyeglasses. One diopter is equal to a one meter focal length. In photography, diopter is used in connection with close-up lenses and viewfinder eyepieces, in relation to correcting the camera viewfinder eyepiece to the photographer's eyesight.

Discontinuous light source—Discontinuous light sources include fluorescent, sodium vapor, neon, metal halide and mercury vapor lights. The spectral energy distribution

of these sources is not smooth, featuring peaks and valleys across the photographic spectrum.

Dodging—Reducing the amount of light that hits the photographic paper when making a black & white print. Results in a brighter shadow area that shows more detail.

Double exposure—When two or more images are recorded on the same piece of film; generally accomplished for special effect.

Double-exposure filter—A filter that allows a photographer to capture a double exposure photo on a white (or any other) background.

Electromagnetic spectrum—The complete range of wavelengths or frequencies of electromagnetic radiation extending from gamma rays to the longest radio waves. This spectrum includes visible light.

Enhancing filter—Also known as intensifying or didymium filters, these filters are made of glass blended with rare-earth elements that selectively transmit and absorb specific wavelengths of light, producing an intensification of color in the final image. The degree of enhancement that the filters create is dependent on the subject and film. A given color can become only so saturated on any particular film. Therefore, colors that are less intense to begin with will show more of a gain in saturation than the more intense colors in the scene.

Filter—A device made of glass, plastic, or other material that selectively absorbs some of the wavelengths of light that pass through it to alter, and improve, the way that a subject or scene is recorded.

Filter factor—A figure indicating how much light a filter absorbs, thus requiring an increase in exposure when the filter is used. Filter factors are not, however, equivalent to f-stops.

Filter frame—A device (also referred to as a "filter holder") into which gelatin, polyester and resin filters are placed, which screws or clamps onto the camera lens. Because the thickness of the filters from different manufacturers varies, filters from one company are generally not usable in a competitor's holder.

Fisheye lens—A lens that is designed so the angle of view diagonally is much greater (usually 180°) in relation to the angle of view horizontally or vertically. They produce an image with curved lines outside the center area

Flat lighting—Low contrast light that produces an image lacking contrast.

Fluorescent light source—A discontinuous light source having strong spikes of output at certain wavelengths. Color-compensating filters can improve color balance with such lighting. It is important to remember that no filter can add wavelengths of light that are not present in the incoming light. Filters can only remove wavelengths in an effort to smooth out the incoming light to match the

wavelengths of daylight or tungsten for which the chosen film is balanced.

Focal length—Distance from the principal plane in the lens (known to the lens designer) to the point at which the lens forms an image of a subject at infinity. The focal length of a lens is the same no matter where or how it is used—and regardless of what image format it is to cover.

Fog filters—A filter that softens the sharpness of the lens and lowers contrast. Fog filters are capable of veiling the entire photo in a white haze simulating real fog. Backlighting, early morning light and a wide aperture enhance the effect. Combining several together intensifies the effect even more. Using such filters without a lens shade also increases the degree of diffusion.

Gelatin filter—Gelatin filters are made by dissolving precisely formulated dyes in liquid gelatin and coating the solution onto prepared sheets of glass. After the coating is dry, the gelatin film is stripped from the glass, coated with lacquer and cut to size. Prepared in this manner, gelatin filters have a thickness of 0.1mm plus or minus 0.01mm. Because of their uniform thickness and the precision of the manufacturing process, gelatin filters are least likely to degrade image quality—at least while they're still new. Gelatin filters require the greatest care in storage and handling. The thin lacquer coating offers only limited protection, so they must be handled extremely carefully by the corners or the edges. They also must be cleaned carefully.

Glass filters—Glass filters, other than the least expensive ones, are made from optically clear glass that has been dyed while molten, then cooled and cut into cylinders. The glass is ground with both surfaces perfectly parallel to one another and mounted in a mounting ring that accurately aligns the filter surface parallel to the front lens element. The finer glass filters have anti-reflection coatings like quality lenses, which eliminate the ghosting and flare seen in photos with strong backlighting or where there is a bright light source at the edge of the frame. Uncoated glass filters transmit only 92% of the light that enters them.

Golden hours—The time of day (from an hour before sunset to sunset) that creates dramatic, golden light. This light is ideal for many photographic endeavors.

Graduated filter—A photographic filter whose color or density varies from one part of the filter to another.

Grain-of-wheat bulb—A tiny, low-output lightbulb capable of producing a point source of light.

Gray card—A card that reflects a known amount (18%) of the light falling on it. Metering from a gray card provides accurate exposure information in situations when the subject is not of average reflectance.

Haze cutting filter—Atmospheric haze is a mixture of water vapor, hydrocarbons and airborne dust particles that scatter the shorter wavelengths of sunlight. When this scattered light reaches the camera it is recorded

as a bluish cast on color film, or a lowering of contrast on black & white film. Haze filters are designed to penetrate this haze, reducing the bluish cast of distant scenes on color film and raising the contrast of the image on black & white emulsions. They have little effect on the yellowish-brown smog increasingly present from man-made pollutants.

High contrast lighting—A small light source, like a spotlight, or a large light source far from the subject, like the sun, creates a scene with high contrast. In other words, the transition from highlight to shadow areas in the scene is quite sharp and pronounced. There are filters available to both increase and decrease overall contrast of a scene. A softening filter can be used to smooth the transition from lighter to darker areas.

Highlight—A very bright area in a print, transparency or scene or, conversely, a very dark area in a negative.

Image-editing program—A software program, such as Photoshop®, which allows users to make improvements to their images digitally once the image is brought into the computer.

Incident light meter—An exposure meter that measures the light that falls on the subject. The reading is unaffected by the reflectance of the subject.

Infrared film—Film type capable of capturing infrared radiation, which is not visible to the eye.

Lens flare—Image degradation causing a haze-like appearance in a photo. Lens flare can appear with any lens on any camera if the sun or a bright light source shines directly on the lens surface or when photographing against bright white backgrounds. Flare may also show up with some lenses when the subject or scene includes very bright areas. Flare can be created by light reflections on lens surfaces or the interior of lens barrels.

Lens shade—An accessory or part of the lens that eliminates unwanted light from reaching the lens and causing flare. A lens shade must be used even with multicoated lenses as the two serve different purposes. The lens shade reduces flare by eliminating the unwanted light, the multi-coating does the same but with the light needed to form the image on the film.

Light-balancing filters—Light-balancing filters are designed to adjust the color temperature of the available light to that for which the film is balanced. The adjustment they offer, however, is smaller, more in the range of 200–300K, as opposed to the 1500–2300K range of conversion filters.

Low contrast lighting—An extended light source, like the sky on a heavily overcast day, produces low scene contrast. In other words, the transition from lighter to darker areas in the scene is soft. There are filters available to both increase and decrease overall contrast of a scene.

Manual mode—A mode of camera operation in which both the shutter speed and aperture are selected by the photographer.

Mercury vapor light—These light sources, used frequently in industrial and outdoor areas, do not contain a continuous spectrum of light, so their output cannot be corrected by broadly-acting color-correction or light-balancing filters. Instead, these light sources have strong spikes of output at some wavelengths. The use of color-compensating filters can improve color balance with such lighting. It is important to remember that no filter can add wavelengths of light that are not present in the incoming light. Filters can only remove wavelengths in an effort to smooth out the incoming light to match the wavelengths of daylight or tungsten for which the chosen film is balanced.

Midtone—The area of a print, transparency or scene that is neither shadow or highlight.

Multi-coating—Used on all high quality lenses today. The coating reduces the amount of light reflected on the glass surface and thus reduces flare and increases the contrast and color saturation.

Multi-image prism filter—Multi-image filters consist of several glass surfaces of different shapes and positioning. All are designed to produce multiple images of the subject during a single exposure. Some produce a central image surrounded by repetitions, others produce a number of repetitions without the central image. Other multi-image filters produce a series of parallel images with the subject reproduced fully in one image and partially in others. Several multi-image filters are available with color foils beneath the prisms, resulting in multi-colored multi-images.

Negative film—Film that produces a negative image when exposed and developed.

Neutral density filter—A filter designed to reduce exposure without affecting color balance or contrast.

Non-chromatic colors—Those colors that are not a component of daylight, such as tan or burgundy.

Panchromatic film—Film that is sensitive to all—or most—of the visible spectrum.

Polarization—When randomly vibrating light is scattered, some of it ends up vibrating more strongly in one plane than in all others. This scattered light is said to be polarized.

Polarizer—Before TTL (through-the-lens) metering, autofocus and autoexposure cameras, all photographic polarizers were the linear type, consisting of a foil of polarizing material between two sheets of glass. These new technologies rely on a beamsplitter to send part of the light entering through the lens to the meter and autofocus mechanism and part to the viewfinder. Because of the beamsplitter, light entering the meter is partially polarized. A linear polarizer placed over the lens in this type of system acts as a second polarizer, blocking light to the meter in amounts depending on the angle between the beamsplitter and the polarizing filter. Circular polarizers eliminate these problems.

Polarizing filter—A filter that reduces the reflections from glass and water by blocking

light waves that are vibrating at particular angles to the filter.

Polyester filter—These filters are made from high-quality polyester-base materials to which dyes have been added. They are rapidly replacing gelatin-based filters for all but the most precise scientific applications. Polyester filters are available in a wide range of types at reasonable cost. They are tough, impervious to moisture and easy to clean.

Pop filter—Strongly-colored filters that are used to achieve special effects with color film. Also known as "fantasy" filters, they are available in pink, purple, violet and orange as well as red, green and blue.

Reflected light meter—An exposure meter that measures the light reflected from the subject. Exposure meters built into cameras are of the reflected type. The meter reading is affected by the reflectance of the subject.

Reflectors—A device (normally white, silver or gold) used to reflect light from another source onto a subject. Commonly used to provide fill light.

Refraction—A condition in which a light ray is deflected from a straight path as it passes from one medium, such as air, to another, such as glass.

Resin filters—Acrylic resin filters were first popularized as special effect filters in the 1970s, but have since grown into a wide range of filter types from numerous manufacturers. Unlike gelatin and polyester filters, resin filters do not need to be one solid color, but can be manufactured with clear areas graduating to color, or one color graduating into another, or with many other characteristics. Resin filters can take much rougher treatment than gelatin or polyester, yet are lightweight for their size. Given the same care as camera lenses, these filters will last for years.

Shadow—The darkest area of a print, transparency or scene, or, conversely, the lightest area of a negative.

Shutter priority mode—A mode of automatic exposure in which the photographer selects the shutter speed and the camera sets the appropriate aperture.

Silhouette—A scene or photograph in which the subject is much darker than the bright background.

Skylight filter—A filter that can be used on the lens at all times that produces a warming effect.

Sodium vapor light—These light sources, used frequently in industrial and outdoor areas, do not contain a continuous spectrum of light, so their output cannot be corrected by broadly-acting color-correction or light-balancing filters. Instead, these light sources have strong spikes of output at certain wavelengths. Color-compensating filters can improve color balance with such lighting. It is important to remember that no filter can add wavelengths of light that are not present in the incoming light. Filters can only

remove wavelengths in an effort to smooth out the incoming light to match the wavelengths of daylight or tungsten for which the chosen film is balanced.

Softbox diffuser—A cloth box-like attachment that is affixed to a light source to diffuse and soften the quality of the light.

Soft-focus filter—A filter that produces an image that is haloed to give the image a luminous appearance. This effect is often desirable in portrait and fashion photography, and also in advertising images of beauty products, where the softened effect adds a more glamorous feeling to the image.

Softening filter—Softening filters can be grouped into four different types according to their design. The first type has a random pattern of waves, bubbles, dimples or tiny lens elements in the filter. The second has a regular pattern of concentric circles or dimples. The third type has an overall texture to it and the fourth has a net or random black pattern. While softening filters in the first two types are designed to leave some of the image sharp, those of the third type produce an overall, even reduction in image sharpness.

Spectral distribution range—A graphical display of the energy given off by a particular source at various wavelengths, usually charted in terms of relative sensitivity and wavelength.

Speed filter—Filter used to create a sense of motion in an image when the subject is stationary.

Spherical aberration—A lens defect that causes image characteristics to vary with the wavelength of light entering the lens.

Split diffusion—A technique in which softening filters are used to simulate the effect of sharp areas/unsharp areas in the same photo. This requires double exposing the film, with one exposure made without the filter and a second exposure made through the filter. This is most effective in the studio where a portion of the subject, or the background, is shot with heavy diffusion on the lens, and then with the filter removed, another light exposes the subject in sharp focus. Portraits can be done in this way if the filter is removed quickly enough so that the subject doesn't move between exposures.

Split-field filter—A filter consisting of a close-up filter in $1/2$ of the retaining ring and clear glass, or nothing, in the other half. This filter allows very close and distant objects to be brought into focus at the same time, creating apparent increases in depth of field.

Spotlight—A light designed to direct an intense, narrow beam of light upon a subject or a small area of a scene.

Spot meter—A reflected light meter that only measures a small area of the subject. A spot meter can be built into the camera or be a separate accessory. The area that is measured is clearly indicated on the focusing screen in the camera or in the viewfinder of an accessory spot meter.

Star filter—These filters are made from glass or resin that has been etched in a fine grid pattern. The depth, spacing and pattern of the grid determine the star pattern. Most star filters have the pattern evenly distributed over the entire surface. The size and intensity of the light source as well as the darkness of the surroundings and the lens aperture used affect the final result. The filters themselves require no adjustment in exposure.

Step-up/step-down rings—An accessory used to adapt round filters of one size for use on a lens that requires a different size. Care must be taken that the adapter or the filter does not intrude into the field of view of the lens, causing vignetting.

Stop down—To decrease the size of the aperture of a lens.

Subtractive primary colors—Colors that are created by combining equal amounts of the additive primaries. These colors are magenta (red and blue combined), yellow (red and green combined) and cyan (blue and green combined).

Sunset filter—A filter used to warm the color temperature and increase color saturation of a scene.

Through-the-lens meter (TTL)—TTL stands for "Through The Lens." It is usually used in connection with a light-metering system that measures the light through the camera lens or a dedicated flash system that measures the flash reflected from the subject through the lens.

Transparency film—Records a positive image on the film, an image where the colors are the same as in reality. Black is recorded as black, and white as white.

Tripod—A camera accessory to support the camera for steadier operation than handheld. Necessary or recommended with longer shutter speeds and/or longer focal length lenses.

Tungsten film—Color film balanced to reproduce accurate color renditions when the light source used to illuminate the scene has a color temperature of 3200K. Also called Type B film.

Tungsten light—Also called incandescent light, this is the type of light that is emitted from standard household-type bulbs.

Type B film—See Tungsten film.

Ultraviolet (UV) Filter—This type of filter absorbs the ultraviolet radiation commonly found in mountain or marine environments. While this radiation is invisible to the eye, it affects the film by increasing exposure of the blue layer. For color transparency film, the UV (0) filter is available. Like the skylight filter, it can be left on the lens at all times, but unlike the skylight filter, it gives no warming effect.

Vignetting—Darkening at the corners and sides of an image. This can be done artificially to emphasize the main subject (common in portraiture). It can also be caused by a filter or lens shade that is too small for the focal length and/or diameter of the lens, or

by shifting a lens beyond its covering power. Some wide-angle lenses (especially extreme wide-angle lenses) also exhibit a darkening on the corners, but this is not vignetting.

Visible light—Radiation perceptible to the human eye that has a wavelength between about 400 nanometers and 700 nanometers.

Warming filter—A filter that decreases the color temperature of a scene. It is most noticeable in the midtone and shadow areas.

White point—In digital photography, setting the "white point," the point of neutral balance where "white" is rendered without color cast, either automatically or manually, corresponds to selecting daylight or tungsten balanced film, or using a correction filter over the lens.

Wide angle lens—A lens with a focal length shorter than the standard. There are two optically different wide angle lens designs. An optically true wide angle design lens must be close to the film plane and can therefore not be used on SLR cameras. Such lenses are used on large format and some special cameras made for smaller formats. A retrofocus wide angle lens is necessary for SLR cameras.

Zone System—A subject evaluation and metering system where the different subject brightness values from white to black are broken down into ten zones. Black & white film developing times are adjusted to produce a black & white negative of normal contrast (printable on #2 paper),

no matter what the contrast range of the original subject might have been.

Zoom lens—A lens design where the focal length can be changed within a certain range by moving some of the lens elements. The range of focal lengths is called the zoom range. True zoom lenses stay in focus when the focal length is changed.

ABOUT THE AUTHORS

STAN SHOLIK has spent over two years as a commercial/advertising illustrative photographer. During that time, he has developed a national reputation in a wide range of technology-oriented specialties for his clients in the computer, electronics, medical device and food industries. Early in his career he began specializing in close-up/macro photography, motion simulation and in-camera photo composition to enhance the images created with his large-format cameras. The acquisition of a high-end computer workstation in 1993 enhanced his capabilities in all of these areas, allowing him to create images that could not be created cost-effectively with the camera alone. He has also gained a reputation as a writer on both conventional and digital imaging topics with articles in *View Camera Magazine, Camera Arts, Photo Lab Management, Petersen's PhotoGraphic* and *Pro Photo*. His first book, *Macro and Close-up Photography Handbook,* also coauthored with Ron Eggers, was published by Amherst Media in 2000. Self-taught as a photographer, he holds a BS in Physics and an MA in English from Carnegie Mellon University in Pittsburgh, PA.

RON EGGERS is a Senior Editor with NewsWatch Feature Service. He is also a Contributing Editor with several consumer and professional photography magazines, including *Petersen's PhotoGraphic, Photo Electronic Imaging* and *Rangefinder.* His articles, pictorials, and photo-features have appeared in numerous magazines and newspapers in North America, Europe and Asia. He began his professional editorial career while still in high school, covering local entertainment venues and writing film reviews for a daily newspaper. Over the years, he's covered local government, art, architecture, engineering and several other topics. Writing about photography in the mid 1970s, his first photo article was an interview with Ansel Adams at his home in Carmel. He started writing about computers for an in-flight magazine in the early 1980s. By the late 1980s, the two specialties converged. Eggers is also an active photographer. Over the years, he has photographed every president from Lyndon B. Johnson to Bill Clinton, including extensive coverage of Richard Nixon and a private session with the senior President Bush. He's also covered such historic events as the first space shuttle landings, the fall of the Berlin Wall and the civil unrest in Los Angeles. He continues to handle editorial photo assignments and add to his stock image library. He coauthored *Macro and Close-up Photography Handbook* with Stan Sholik. Ron's most recent book, *Basic Digital Photography,* was published by Amherst Media in 2000.

INDEX

Other Books from
Amherst Media™

Basic 35mm Photo Guide, 5th Edition
Craig Alesse

Great for beginning photographers! This book is designed to teach 35mm basics step-by-step—completely illustrated. Features the latest cameras. Includes: 35mm automatic, semi-automatic cameras, camera handling, *f*-stops, shutter speeds, and more! $12.95 list, 9x8, 112p, 178 photos, order no. 1051.

Build Your Own Home Darkroom
Lista Duren & Will McDonald

This classic book teaches you how to build a high quality, inexpensive darkroom in your basement, spare room, or almost anywhere. Includes valuable information on: darkroom design, woodworking, tools, and more! $17.95 list, 8½x11, 160p, 50 photos, many illustrations, order no. 1092.

Into Your Darkroom Step by Step
Dennis P. Curtin

This is the ideal beginning darkroom guide. Easy to follow and fully illustrated each step of the way. Includes information on: the equipment you'll need, setup, making proof sheets and much more! $17.95 list, 8½x11, 90p, hundreds of photos, order no. 1093.

Wedding Photographer's Handbook
Robert and Sheila Hurth

A complete step-by-step guide to succeeding in the world of wedding photography. Packed with shooting tips, equipment lists, must-get photo lists, business strategies, and much more! $29.95 list, 8½x11, 176p, index, 100 b&w and color photos, diagrams, order no. 1485.

Lighting for People Photography, 2nd Edition
Stephen Crain

The up-to-date guide to lighting. Includes: setups, equipment information, strobe and natural lighting, and much more! Features diagrams, illustrations, and exercises for practicing the techniques discussed in each chapter. $29.95 list, 8½x11, 120p, 80 b&w and color photos, glossary, index, order no. 1296.

Camera Maintenance & Repair Book 1
Thomas Tomosy

An illustrated guide by a master camera repair technician. Includes: testing camera functions, general maintenance, basic tools and where to get them, basic repairs for accessories, camera electronics, plus "quick tips" for maintenance and more! $29.95 list, 8½x11, 176p, 100+ photos, order no. 1158.

Camera Maintenance & Repair Book 2
Thomas Tomosy

Build on the basics covered in book 1, with advanced techniques. Includes: mechanical and electronic SLRs, zoom lenses, medium format cameras, and more. Features models not included in book 1. $29.95 list, 8½x11, 176p, 150+ photos, charts, tables, appendices, index, glossary, order no. 1558.

Restoring the Great Collectible Cameras (1945-70)
Thomas Tomosy

More step-by-step instruction on how to repair collectible cameras. Covers postwar models (1945–70). Hundreds of illustrations show disassembly and repair. $34.95 list, 8½x11, 128p, 200+ photos, index, order no. 1573.

Big Bucks Selling Your Photography, 2nd Edition
Cliff Hollenbeck

A completely updated photo business package. Includes starting up, getting pricing, creating successful portfolios and using the internet as a tool! Features setting financial, marketing and creative goals. Organize your business planning, bookkeeping, and taxes. $17.95 list, 8½, 128p, 30 photos, b&w, order no. 1177.

Leica Camera Repair Handbook
Thomas Tomosy

A detailed technical manual for repairing Leica cameras. Each model is discussed individually with step-by-step instructions. Exhaustive photographic illustration ensures that every step of the process is easy to follow. $39.95 list, 8½x11, 128p, 130 b&w photos, appendix, order no. 1641.

Freelance Photographer's Handbook

Cliff & Nancy Hollenbeck

Whether you want to be a freelance photographer or are looking for tips to improve your current freelance business, this volume is packed with ideas for creating and maintaining a successful freelance business. $29.95 list, 8½x11, 107p, 100 b&w and color photos, index, glossary, order no. 1633.

Infrared Landscape Photography

Todd Damiano

Landscapes shot with infrared can become breathtaking and ghostly images. The author analyzes over fifty of his most compelling photographs to teach you the techniques you need to capture landscapes with infrared. $29.95 list, 8½x11, 120p, 60 b&w photos, index, order no. 1636.

Wedding Photography:
Creative Techniques for Lighting and Posing, *2nd Edition*

Rick Ferro

Creative techniques for lighting and posing wedding portraits that will set your work apart from the competition. Covers every phase of wedding photography. $29.95 list, 8½x11, 128p, full color photos, index, order no. 1649.

Professional Secrets of Advertising Photography

Paul Markow

No-nonsense information for those interested in the business of advertising photography. Includes: how to catch the attention of art directors, make the best bid, and produce the high-quality images your clients demand. $29.95 list, 8½x11, 128p, 80 photos, index, order no. 1638.

Lighting Techniques for Photographers

Norman Kerr

This book teaches you to predict the effects of light in the final image. It covers the interplay of light qualities, as well as color compensation and manipulation of light and shadow. $29.95 list, 8½x11, 120p, 150+ color and b&w photos, index, order no. 1564.

Infrared Photography Handbook

Laurie White

Covers black & white infrared photography: focus, lenses, film loading, film speed rating, batch testing, paper stocks, and filters. Black & white photos illustrate how IR film reacts. $29.95 list, 8½x11, 104p, 50 b&w photos, charts & diagrams, order no. 1419.

How to Operate a Successful Photo Portrait Studio

John Giolas

Combines photographic techniques with practical business information to create a complete guide book for anyone interested in developing a portrait photography business (or improving an existing business). $29.95 list, 8½x11, 120p, 120 photos, index, order no. 1579.

Fashion Model Photography

Billy Pegram

For the photographer interested in shooting commercial model assignments, or working with models to create portfolios. Includes techniques for dramatic composition, posing, selection of clothing, and more! $29.95 list, 8½x11, 120p, 58 photos, index, order no. 1640.

Computer Photography Handbook

Rob Sheppard

Learn to make the most of your photographs using computer technology! From creating images with digital cameras, to scanning prints and negatives, to manipulating images, you'll learn all the basics of digital imaging. $29.95 list, 8½x11, 128p, 150+ photos, index, order no. 1560.

Creating World-Class Photography

Ernst Wildi

Learn how any photographer can create technically flawless photos. Features techniques for eliminating technical flaws in all types of photos—from portraits to landscapes. Includes the Zone System, digital imaging, and much more. $29.95 list, 8½x11, 128p, 120 color photos, index, order no. 1718.

Black & White Portrait Photography

Helen T. Boursier

Make money with b&w portrait photography. Learn from top b&w shooters! Studio and location techniques, with tips on preparing your subjects, selecting settings and wardrobe, lab techniques, and more! $29.95 list, 8½x11, 128p, 130+ photos, index, order no. 1626

The Beginner's Guide to Pinhole Photography

Jim Shull

Take pictures with a camera you make from stuff you have around the house. Develop and print the results at home! Pinhole photography is fun, inexpensive, educational and challenging. $17.95 list, 8½x11, 80p, 55 photos, charts & diagrams, order no. 1578.

Stock Photography

Ulrike Welsh

This book provides an inside look at the business of stock photography. Explore photographic techniques and business methods that will lead to success shooting stock photos—creating both excellent images and business opportunities. $29.95 list, 8½x11, 120p, 58 photos, index, order no. 1634.

Profitable Portrait Photography

Roger Berg

A step-by-step guide to making money in portrait photography. Combines information on portrait photography with detailed business plans to form a comprehensive manual for starting or improving your business. $29.95 list, 8½x11, 104p, 100 photos, index, order no. 1570

Professional Secrets for Photographing Children
2nd Edition

Douglas Allen Box

Covers every aspect of photographing children on location and in the studio. Prepare children and parents for the shoot, select the right clothes capture a child's personality, and shoot story book themes. $29.95 list, 8½x11, 128p, 74 photos, index, order no. 1635.

Telephoto Lens Photography

Rob Sheppard

A complete guide for telephoto lenses. Shows you how to take great wildlife photos, portraits, sports and action shots, travel pics, and much more! Features over 100 photographic examples. $17.95 list, 8½x11, 112p, b&w and color photos, index, glossary, appendices, order no. 1606.

Handcoloring Photographs Step by Step

Sandra Laird & Carey Chambers

Learn to handcolor photographs step-by-step with the new standard in handcoloring reference books. Covers a variety of coloring media and techniques with plenty of colorful photographic examples. $29.95 list, 8½x11, 112p, 100+ color and b&w photos, order no. 1543.

Special Effects Photography Handbook

Elinor Stecker-Orel

Create magic on film with special effects! Little or no additional equipment required, use things you probably have around the house. Step-by-step instructions guide you through each effect. $29.95 list, 8½x11, 112p, 80+ color and b&w photos, index, glossary, order no. 1614.

McBroom's Camera Bluebook, *6th Edition*

Mike McBroom

Comprehensive and fully illustrated, with price information on: 35mm, digital, APS, underwater, medium & large format cameras, exposure meters, strobes and accessories. Pricing info based on equipment condition. A must for any camera buyer, dealer, or collector! $29.95 list, 8½x11, 336p, 275+ photos, order no. 1553.

Family Portrait Photography

Helen Boursier

Learn from professionals how to operate a successful portrait studio. Includes: marketing family portraits, advertising, working with clients, posing, lighting, and selection of equipment. Includes images from a variety of top portrait shooters. $29.95 list, 8½x11, 120p, 123 photos, index, order no. 1629.

The Art of Infrared Photography, *4th Edition*

Joe Paduano

A practical guide to the art of infrared photography. Tells what to expect and how to control results. Includes: anticipating effects, color infrared, digital infrared, using filters, focusing, developing, printing, handcoloring, toning, and more! $29.95 list, 8½x11, 112p, 70 photos, order no. 1052.

Camcorder Tricks and Special Effects, *revised*

Michael Stavros

Kids and adults can create home videos and mini-masterpieces that audiences will love! Use materials from around the house to simulate an inferno, make subjects transform, create exotic locations, and more. Works with any camcorder. $17.95 list, 8½x11, 80p, 40 photos, order no. 1482.

The Art of Portrait Photography

Michael Grecco

Michael Grecco reveals the secrets behind his dramatic portraits which have appeared in magazines such as *Rolling Stone* and *Entertainment Weekly*. Includes: lighting, posing, creative development, and more! $29.95 list, 8½x11, 128p, 60 photos, order no. 1651.

Essential Skills for Nature Photography

Cub Kahn

Learn all the skills you need to capture landscapes, animals, flowers and the entire natural world on film. Includes: selecting equipment, choosing locations, evaluating compositions, filters, and much more! $29.95 list, 8½x11, 128p, 60 photos, order no. 1652.

Photographer's Guide to Polaroid Transfer
2nd Edition
Christopher Grey

Step-by-step instructions make it easy to master Polaroid transfer and emulsion lift-off techniques and add new dimensions to your photographic imaging. Fully illustrated every step of the way to ensure good results the very first time! $29.95 list, 8½x11, 128p, 50 photos, order no. 1653.

Black & White Landscape Photography
John Collett and David Collett

Master the art of b&w landscape photography. Includes: selecting equipment (cameras, lenses, filters, etc.) for landscape photography, shooting in the field, using the Zone System, and printing your images for professional results. $29.95 list, 8½x11, 128p, 80 b&w photos, order no. 1654.

Wedding Photojournalism
Andy Marcus

Learn the art of creating dramatic unposed wedding portraits. Working through the wedding from start to finish you'll learn where to be, what to look for and how to capture it on film. A hot technique for contemporary wedding albums! $29.95 list, 8½x11, 128p, b&w, over 50 photos, order no. 1656.

Photographer's Guide to Shooting Model & Actor Portfolios
CJ Elfont, Edna Elfont and Alan Lowy

Learn to create outstanding images for actors and models looking for work in fashion, theater, television, or the big screen. Includes the business, photographic and professional information you need to succeed! $29.95 list, 8½x11, 128p, 100 photos, order no. 1659.

Photo Retouching with Adobe® Photoshop®
Gwen Lute

Designed for photographers, this manual teaches every phase of the process, from scanning to final output. Learn to restore damaged photos, correct imperfections, create realistic composite images and correct for dazzling color. $29.95 list, 8½x11, 120p, 60+ photos, order no. 1660.

Make Money with Your Camera
David Neil Arndt

Learn everything you need to know in order to make money in photography! David Arndt shows how to take highly marketable pictures, then promote, price and sell them. Includes all major fields of photography. $29.95 list, 8½x11, 120p, 100 b&w photos, index, order no. 1639.

Creative Lighting Techniques for Studio Photographers
Dave Montizambert

Master studio lighting and gain complete creative control over your images. Whether you are shooting portraits, cars, tabletop or any other subject, Dave Montizambert teaches you the skills you need to confidently create with light. $29.95 list, 8½x11, 120p, 80+ photos, order no. 1666.

Storytelling Wedding Photography
Barbara Box

Barbara and her husband shoot as a team at weddings. Here, she shows you how to create outstanding candids (which are her specialty), and combine them with formal portraits (her husband's specialty) to create a unique wedding album. $29.95 list, 8½x11, 128p, 60 b&w photos, order no. 1667.

Fine Art Children's Photography
Doris Carol Doyle and Ian Doyle

Learn to create fine art portraits of children in black & white. Included is information on: posing, lighting for studio portraits, shooting on location, clothing selection, working with kids and parents, and much more! $29.95 list, 8½x11, 128p, 60 photos, order no. 1668.

Infrared Portrait Photography
Richard Beitzel

Discover the unique beauty of infrared portraits, and learn to create them yourself. Included is information on: shooting with infrared, selecting subjects and settings, filtration, lighting, and much more! $29.95 list, 8½x11, 128p, 60 b&w photos, order no. 1669.

Black & White Photography for 35mm
Richard Mizdal

A guide to shooting and darkroom techniques! Perfect for beginning or intermediate photographers who want to improve their skills. Features helpful illustrations and exercises to make every concept clear and easy to follow. $29.95 list, 8½x11, 128p, 100+ b&w photos, order no. 1670.

Macro and Close-up Photography Handbook
Stan Sholik & Ron Eggers

Learn to get close and capture breathtaking images of small subjects—flowers, stamps, jewelry, insects, etc. Designed with the 35mm shooter in mind, this is a comprehensive manual full of step-by-step techniques. $29.95 list, 8½x11, 120p, 80 photos, order no. 1686.

Watercolor Portrait Photography:
The Art of Polaroid SX-70 Manipulation

Helen T. Boursier

Create one-of-a-kind images with this surprisingly easy artistic technique. $29.95 list, 8½x11, 120p, 200+ color photos, order no. 1698.

Techniques for Black & White Photography:
Creativity and Design

Roger Fremier

Harness your creativity and improve your photographic design with these techniques and exercises. From shooting to editing your results, it's a complete course for photographers who want to be more creative. $19.95 list, 8½x11, 112p, 30 photos, order no. 1699.

Corrective Lighting and Posing Techniques for Portrait Photographers

Jeff Smith

Learn to make every client look his or her best by using lighting and posing to conceal real or imagined flaws—from baldness, to acne, to figure flaws. $29.95 list, 8½x11, 120p, full color, 150 photos, order no. 1711.

Basic Digital Photography

Ron Eggers

Step-by-step text and clear explanations teach you how to select and use all types of digital cameras. Learn all the basics with no-nonsense, easy to follow text designed to bring even true novices up to speed quickly and easily. $17.95 list, 8½x11, 80p, 40 b&w photos, order no. 1701.

Make-Up Techniques for Photography

Cliff Hollenbeck

Step-by-step text paired with photographic illustrations teach you the art of photographic make-up. Learn to make every portrait subject look his or her best with great styling techniques for black & white or color photography. $29.95 list, 8½x11, 120p, 80 full color photos, order no. 1704.

Professional Secrets of Natural Light Portrait Photography

Douglas Allen Box

Learn to utilize natural light to create inexpensive and hassle-free portraiture. Beautifully illustrated with detailed instructions on equipment, setting selection and posing. $29.95 list, 8½x11, 128p, 80 full-color photos, order no. 1706.

Portrait Photographer's Handbook

Bill Hurter

Bill Hurter has compiled a step-by-step guide to portraiture that easily leads the reader through all phases of portrait photography. This book will be an asset to experienced photographers and beginners alike. $29.95 list, 8½x11, 128p, full color, 60 photos, order no. 1708.

Basic Scanning Guide For Photographers and Creative Types

Rob Sheppard

This hands-on, easy-to-read, how-to manual offers practical knowledge of scanning. It also includes excellent sections on the mechanics of scanning and scanner selection. $17.95 list, 8½x11, 96p, 80 photos, order no. 1702.

Traditional Photographic Effects with Adobe Photoshop

Michelle Perkins and Paul Grant

Use Photoshop to enhance your photos with handcoloring, vignettes, soft focus and much more. Every technique contains step-by-step instructions for easy learning. $29.95 list, 8½x11, 128p, 150 photos, order no. 1721.